The Focal Digital Imaging A–Z

The Focal Digital Imaging A–Z

ADRIAN DAVIES

AMSTERDAM • BOSTON • HEIDELBERG • LONDON
NEW YORK • OXFORD • PARIS • SAN DIEGO
SAN FRANCISCO • SINGAPORE • SYDNEY • TOKYO
Focal Press is an imprint of Elsevier

Focal Press
An imprint of Elsevier
Linacre House, Jordan Hill, Oxford OX2 8DP
30 Corporate Drive, Burlington, MA 01803

First published 1998
Reprinted 1998, 2000
Second edition 2005

British Library Cataloguing in Publication Data
A catalogue record for this book is available from the British Library

Library of Congress Cataloguing in Publication Data
A catalogue record for this book is available from the Library of Congress

ISBN 0 240 51980 9

For information on all Focal Press publications
visit our website at www.focalpress.com

Typeset by SPI Publisher Services, Pondicherry, India
Printed and bound in Italy

Working together to grow
libraries in developing countries

www.elsevier.com | www.bookaid.org | www.sabre.org

ELSEVIER BOOK AID International Sabre Foundation

Acknowledgements

I am grateful to the following individuals and companies who have kindly lent equipment, or provided information to help me in the production of this book: Greg Collins of Olympus, UK, Phil Fennessy of Kodak, Tony Riley, Epson, UK, Adobe, UK, Gretag Macbeth, ColourVision, Foveon, Fuji, UK.

Christina Donaldson and Georgia Kennedy at Focal Press for their help and constant encouragement throughout.

My wife and family for putting up with my frequent absences whilst working at my PC!

Introduction

The first edition of this book was published in 1998, and when I decided to update it I rather naively thought it would take a couple of weeks. Instead, the huge changes that have occurred in the industry since then have necessitated re-writing virtually the whole book, and adding many new terms to it. Since that time, digital cameras have become commonplace, outselling film cameras, whilst many of the big industry 'names' have gone. The work of the photographer has changed too. The job of the photographer was often finished when the film was taken to the lab for processing. Now, photographers may need to undertake time consuming post-capture processing, captioning and filing to ensure a smooth and efficient workflow. They need to understand at least the basics of colour management, whether they be making their own prints on an ink jet printer, or having them published in books and magazines. The use of the Internet has expanded enormously, becoming a valuable means of marketing and transmitting images, as well as a huge information source when researching books like this!

The technologies involved with digital imaging cross many boundaries – photography, IT, graphics, reprographics to name but a few. Each of these areas has its own language or jargon, often incomprehensible to people outside that particular sector. This book is an attempt to bring together in one place those terms relevant to digital imaging. It does not pretend to be a comprehensive glossary for each of the areas mentioned.

I decided to increase the scope and usefulness of the book by writing longer entries for some of the more important topics. I hope to continue to do this by regularly posting new material on the web site associated with the book – www.focalpress.com/companions/0240519809. I would be grateful to hear comments from readers regarding new terms to be added (or removed!).

Adrian Davies
apdavies@nescot.ac.uk
February, 2005

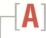

2

4/3 Four thirds type

The name given by **Olympus**® to **CCD** and **CMOS** sensors for its range of specifically designed **digital** SLR cameras such as the E1®.

8 bit

An image where 8 bits are allocated for each **pixel** giving a possible range of 256 tones or colours (2^8).

16 bit

An image where 16 bits are allocated for each pixel giving a possible range of 65 536 tones or colours (2^{16}).

24 bit

An image where 24 bits are allocated for each pixel giving a possible range of 16.7 million (2^{24}) colours. Such images would normally consist of three 8 bit **channels** (usually red, green and blue).

Aa

Absolute colorimetric rendering

A **rendering intent** in **Adobe Photoshop**® and other image processing programs, where in-gamut colours are mapped exactly from one **colour space** to another, for example colours in a commercial logotype. Scaling of colours to white point destination is not performed. Rendering intent maintains colour accuracy, though at the expense of preserving relationships between colours. It is useful to simulate a white point on a non-neutral substrate (e.g., newspaper).

Accelerator card

An extra circuit board, or card which fits inside the computer, designed specifically to speed up certain types of operation, or certain programs, such as **Adobe Photoshop**®. These may contain digital signal processors (DSPs) which help to speed up mathematically intensive calculations or operations.

Access time

In computing, the amount of time taken to retrieve information from a peripheral device such as a disc drive Usually quoted in milliseconds (ms).

Acquire module

See **Plug-in**

Actions

The facility within **Adobe Photoshop**® and other imaging programs to record a series of operations, and apply them automatically to other images.

Active matrix LCD

In this type of **LCD** display, each liquid crystal cell has its own transistor, providing a stronger charge, leading to better colour fidelity. They are generally more expensive than **passive matrix displays**.

Acutance

A measure of the transition between edges in an image. Filters such as the unsharp mask increase acutance or edge sharpness.

ADB (Apple® desktop bus)

The original **bus** used by **Apple**® computers for connecting the **mouse** and other input devices to the keyboard. Replaced by the **USB** connector.

ADC (analogue to digital converter)

Circuitry designed to convert **analogue** signals into **digital** data. This can be fitted inside a computer or camera to convert analogue signals into digital form.

Additive primary colours

The three primary colours of light are red, green and blue. When mixed in equal proportions, 'white light' is the result. When mixed in varying proportions, all other colours can be synthesised.

See **Subtractive colour**

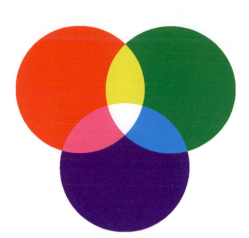

RGB model-additive system

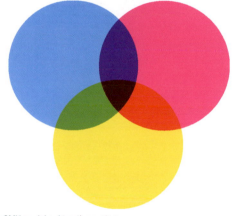

CMY model-subtractive system

Addressability

A measure of the spatial resolution of film recorders; the maximum number of pixels that can be recorded across the widest dimension of the film output. Film recorders depart from convention by expressing their resolution in *K* rather than dots per inch. *K* refers to the number 1024 (kilo ...), i.e., 2^{10}, typical values being 2*K*, 4*K* and 8*K*. For example, a 2*K* film recorder will expose 2048 pixels in the 36 mm width of a 24 × 36 mm format on 35 mm gauge film.

Adjustment layer

A **layer** in **Photoshop** (and similar programs) containing information about adjustments made to images such as **levels**, **curves**, colour balance, etc.

Adobe Acrobat®

A program for producing documents which can be viewed on any other computer (with Acrobat software) regardless of the **operating system**, **hardware** or font configuration. It does this by creating **Portable Document Format** (**PDF**) files.

Adobe InDesign®

A commonly used program for **desktop publishing**.

Adobe Photoshop®

A **pixel**-based image editing program which has become the *de facto* 'industry standard'.

Adobe Premiere®

A video-editing program for desktop computers.

Adobe RGB 1998*

The generally recommended **colour space** for editing **RGB** images which will eventually be converted to **CMYK**. It was originally called SMPTE-240M.

Adobe Type Manager®

A program for improving the appearance of certain fonts on screen.

ADPCM (adaptive differential pulse code modulation)

An audio **compression** scheme for **CD-I** and **CD ROM XA** formats, either to increase the recording time length of audio, or to combine it with other data on the disc.

4

AE (auto exposure)

The facility on cameras to automatically expose the film or sensor with the correct exposure, by measuring the light reflected from the subject.

AF (auto focus)

The ability of most modern cameras to focus automatically on the subject being photographed.

Ageratum effect

The term sometimes used to describe the problem of recording blue or purple flowers (e.g., Bluebells, Ageratums) with colour film. Because of the relatively large amounts of infrared and ultraviolet radiation reflected from these flowers, they often appear pink or purple in film images. **Digital** sensors are generally better than film at recording such subjects.

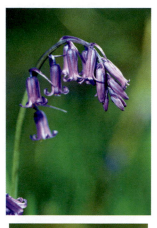

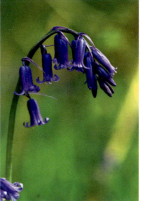

A bluebell flower photographed with colour film (1) and a digital camera (2). The digital version is a much better rendition of the blue colour of the flower.

AIFF (Audio Interchange File Format)

A file format for storing **digital** audio data.

Aim proof

A print produced to give a general idea as to how an image should be reproduced.

Algorithm

A set of mathematical rules, when applied to a problem, will result in a solution. The rules can be applied without judgment, and thus can be programmed into a computer to perform certain functions, e.g., **resampling** an image.

Aliasing

Refers to displays of bitmapped images, where both curved and diagonal straight lines appear to be jagged as they are composed of square pixels (sometimes referred to as staircasing or **jaggies**). Also, when coloured objects fall across groups of pixels on the imaging sensor, **colour aliasing** may occur.

See also **Anti-aliasing**

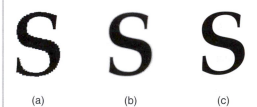

(a) (b) (c)

Aliased text: (a) aliased text, (b) anti-aliased text, (c) vector text

Alpha channel

An 8-bit greyscale representation of an image often used to store any masking, or additional colour information about an image.

See **Channel**

Alphanumeric

Computer data consisting of letters and numbers only.

Amplitude

The strength of a **signal** determining the brightness or loudness. It is measured in **decibels** (dB).

Analogue

A **signal** that represents sound or vision by electrical analogy, e.g., variations in voltage producing corresponding variations in luminance, or vice versa. A silver photographic negative is an analogue representation of a subject.

Analogue to digital conversion

Analogue signals are a continuously variable range of values, used to define sound, colour, tone or even time. For all intents and purposes, a silver-based photographic image is **analogue** in that it can contain an infinite range of tones or colours. The **signal** produced by a **CCD** or **CMOS** sensor is an analogue signal, and must be digitized before the computer can recognize it.

Computers require **binary** data, i.e., a stream of 0s and 1s, and ADC (analogue to **digital** conversion) circuitry in digital cameras; scanners 'sample' the digital signal to produce the required binary data (a process called 'quantization'). This is done by **sampling** the analogue data, and converting it into binary data. In general, the more samples made, the better the image (in standard digital audio systems, for example, the sampling rate used is around 44 600 samples per second).

Animated GIF

See **GIF**

Anonymous FTP

See **FTP**

ANSI (American National Standards Institute)

The ANSI is defined an 8 bit character set that Microsoft Windows® uses to represent **alphanumeric** characters and symbols.

Anti-aliasing

A method of reducing the effect of **aliasing** by averaging the densities of **pixels** at the edges of items such as text, thereby softening their appearance.

Aperture priority

Exposure mode within modern cameras, whereby the user sets the aperture to determine the depth of field within the image, and the camera automatically sets the appropriate shutter speed according to the amount of light present.

Apple®

The manufacturer of the Macintosh computer originally based on the Motorola 68000 series of microprocessors. The Macintosh was the first computer in common use to use a **Graphical User Interface (GUI)** and **mouse** rather than being text driven.

Application

Software program such as **Adobe Photoshop**®.

Approval™ system

A **digital** colour proofing system from Kodak using a **thermal dye sublimation** printing process which uses the same dot structure to print the four **(CMYK)** dye colours onto the page. The dye ribbons in the printer are calibrated to the output inks. The system has the great advantage of being able to print the image onto the same paper stock as the final printed page.

APR [automatic picture replacement (Scitex®)]

The process of substituting a high resolution scan at the pre-press stage, after the document has been laid out using **FPO** low resolution scans.

A/D converters

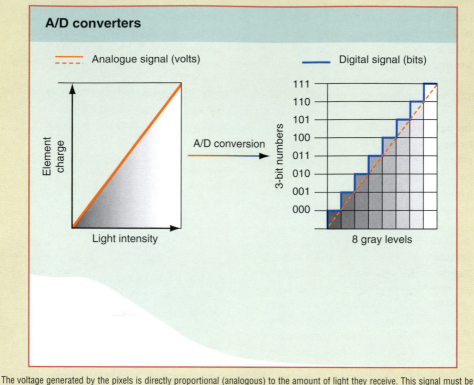

—— Analogue signal (volts) —— Digital signal (bits)

Element charge / Light intensity

A/D conversion

3-bit numbers: 111, 110, 101, 100, 011, 010, 001, 000

8 gray levels

The voltage generated by the pixels is directly proportional (analogous) to the amount of light they receive. This signal must be sampled and converted into binary (digital) data.

APS (advanced photo system)

A photographic format using 24 mm-wide cartridge loaded non-sprocketed film. The system allows three formats on the same roll of film:

C (Classic) format: 3:2 aspect ratio
H (**HDTV**) format: 16:9 aspect ratio
P (Panoramic) format: 3:1 aspect ratio

The basic idea of the system is to transfer photographic data such as date, exposure, use of flash or daylight, etc., to the photofinishing equipment by means of **digital** data recorded onto a transparent magnetic layer coated onto the back surface of the film base and information exchange (ix) circuitry. The system is thus a hybrid system using both **analogue** photographic and **digital** technologies.

Area array CCD

See **CCD**

Area processes

Image processing routines performed on groups or blocks of pixels rather than on single ones. Such processes include **filters** for the enhancement of edges, sharpening and blurring of images.

Artefact

Extraneous **digital** information in an image resulting from limitations in the device used to create it. Examples include **noise**, **aliasing**, **blooming**, and **colour fringing**.

ASCII (American Standard Code for Information Interchange)

The standard codes adopted by most computers for assigning code numbers to letters, numbers and commonly used symbols. Files saved as ASCII files are often called 'text only' files. There are 128 standard ASCII codes, each of which can be represented by a seven digit **binary** number: 0000000 to 1111111.

Aspect ratio

The relationship between the width and height of a recorded or displayed image. For television it is 4:3.

ATA FlashCard

A credit card sized memory device using NAND flash memory. They fit into Type I, II or III **PCMCIA card** slots. Now the largely redundant, they are being replaced by smaller and higher capacity devices such as **CompactFlash**®.

Attachment

Any **digital** file sent with, or 'attached' to, an **Email** message.

AVI (audio video interleave)

The format used by **Windows**® for audio and video data.

AWB (auto white balance)

The ability of a **digital** camera to automatically adjust the colour response of the **CCD** or **CMOS** sensor to a particular colour of light source, such as tungsten.

Bb

8

Back-up

A duplicate copy of data made to prevent loss of data through disc failure.

Banding

Where a continuous varying gradation of tone that is monochrome or coloured is represented by too few grey levels or colours, visible tonal 'bands' are seen. The effect is sometimes known as **contouring** or **posterization**.

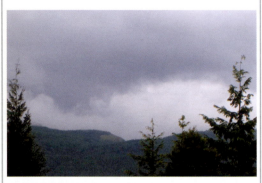

Banding: Image 1 shows the original 16 bit version of the image. Image 2 shows the image reduced to 3 bit (32 levels) exhibiting banding (posterization) in the sky area.

Bandwidth

The difference between the highest and lowest parts of a **signal**, expressed as a range of frequencies. The greater the bandwidth of a transmitted signal, the more data it can carry. Bandwidth is expressed in cycles per second or Hertz (Hz).

Barrel distortion

A lens distortion which causes the image of a square to appear barrel shaped.

Base resolution

The term used in the now largely redundant Kodak **PhotoCD**® system, where the base resolution is 512×768 pixels – the resolution of consumer **NTSC**-based televisions. Other components of the **PhotoCD Image Pac** are fractions or multiples of the base:

Base/4

A PhotoCD image having one quarter the number of pixels as a base resolution image.

Base/16

A PhotoCD image having one sixteenth the number of pixels as a base resolution image.

4 Base

A PhotoCD image having four times the number of pixels of the base resolution image. This image would be suitable for display on an **HDTV** system and is sometimes called '**HDTV** resolution'.

16 Base

A PhotoCD image having 16 times the number of pixels as a base resolution image.

64 Base

A PhotoCD image having 64 times the number of pixels as a base resolution image (found in the **Pro-PhotoCD** format).

Batch processing

Programming a computer to process several images or other files automatically.

Baud rate

A measurement of the speed at which information is transmitted by a **modem** over a telephone line. Baud rates are in terms of bits per second (bps). Typical speeds are 1200, 2400 baud and higher up to 56000 baud. Strictly speaking, at speeds over 1200 bps, the terms baud and bits per second are not completely interchangeable. A 2400 bits per second modem actually runs at 300 baud, but it moves 4 bits per baud ($4 \times 300 = 1200$ bits per second).

Bayer array

The pattern of coloured **filters** on a typical **CCD** or **CMOS** imaging sensor, where the green filtered pixels present are twice as many as red and blue. This is an attempt by manufacturers to mimic the spectral sensitivity of the human eye, which is most sensitive to the green region of the spectrum.
See **CCD**, **RGBE**

Bernoulli drive

One of the first types of removable disc storage systems, now largely redundant. It made use of the Bernoulli Principle, which explains how an aerofoil gives an aeroplane lift. When the flexible recording media in the disc spins at high speed, the created air pressure forces the medium to rise up towards the read/write head. There is no contact between the head and disc, since there is a gap of about 10 millionths of an inch between them. The advantage of this system is that in the case of a power failure or mechanical knock, the disc loses lift and falls away from the head, thus greatly reducing the risk of physical damage to the disc.

Beta version

A pre-release version of **software** which is sent out to accredited testers for fault or **bug** finding.

Bezier curve

In 'object-oriented' application drawing programs, bezier **curves** are mathematically defined curves between two points (bezier points). The shape of the curve can be altered by dragging '**handles**' on the points. In **Adobe Photoshop**®, bezier curves are used to define the '**path**' selection **tool**.

Bezier curve: A curve produced by laying down a series of points (bezier points). The line across the centre is a handle for altering the shape of the curve.

Bicubic

A method of **interpolation** whereby, in order to increase resolution, the value of the new pixel is determined by averaging all those surrounding it. It is the most accurate form of interpolation, but is more time-consuming.

Bicubic sharper

A method of **interpolation** introduced in **Photoshop** CS recommended for use when **downsampling** images.

Bicubic smoother

A method of **interpolation** introduced in **Photoshop** CS recommended for use when upsampling images.

Bilevel

Images composed only of black and white.
See **Binary**

Bilinear

A method of **interpolation**, whereby in order to increase resolution, the value of the new pixel is determined by a weighted average of the four pixels surrounding the pixel of interest.

Binary

10

A numerical coding system using two digits,
0 and 1.
Two binary digits (bits) can give four possible
combinations:

00, 01, 10, 11

Three bits can give 2^3 possible combinations:

000, 001, 010, 011, 100, 101, 110, 111

A binary 'image' consists of just black and white
tones.

Bit

Short form for 'binary digit' – a single number
having the value either zero or one, which may
represent the states, 'on' or 'off'. Eight bits (b)
make up one **byte** (B).

Bit depth

Apart from spatial resolution, the other aspect of
image resolution is bit depth, i.e., how many
computer bits are allocated to each pixel. Most
monochrome **digital** images are composed of 8
bits per pixel, giving a possible 256 tones (2^8),
whilst the majority of colour images will be
composed of three channels (red, green and blue),
each of which is composed of 8 bits per pixel,
giving a possible 16.7 million colours
(i.e., 2^{24}: $256 \times 256 \times 256$).

It is possible to increase the number of bits per
pixel, when capturing images, either with a **scanner**
or **digital camera**, to achieve a better tonal range.
Twelve, fourteen and sixteen bits per pixel can be
recorded, allowing greater flexibility when
processing images. Because a 16 bit image has
twice as many bits per pixel as an 8 bit image, it
will, therefore be twice as large.

Monochrome greyscale image in 2 bits per pixel (four levels of grey), 3 bit (eight levels) and 5 bit (32 levels), showing the
increasing number of tones. The 8 bit image, with 256 greys is 'continuous tone'.

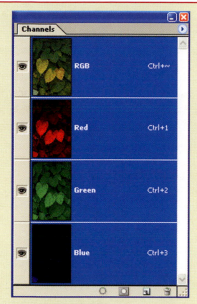

'Channels' dialog box in **Photoshop**

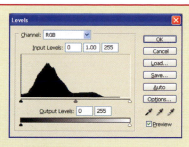

Histogram for colour image.

The histogram was adjusted by the same amount for both the 8 and 16 bit images

When the histogram for the 8 bit image is adjusted, a 'combing' effect is seen, where gaps appear in the graph. This can lead to posterization.

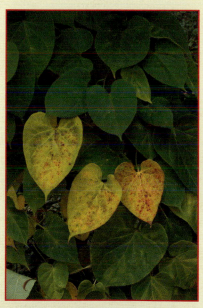

The image of leaves was opened, from the RAW file, in both 8 and 16 bit versions.

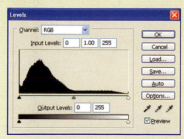

When the histogram for the 16 bit image is adjusted, no gaps appear.

12

Bitmap

1. A **binary** representation of an image, in which each bit, is mapped to a point **(pixel)** on the **output** device, where the point will either be on (black) or off (white) or vice versa.
2. An image formed by a rectangular grid of pixels, each one of which is assigned an **address** as X, Y co-ordinates and a value, either **greyscale**, or colour.

Bitmapped

An image which is converted to a **bitmap**.

Bits per pixel

The number of bits used to represent the colour value of each pixel in a digitized image. One bit per pixel displays two colours or tones (black or white), 2 bits – four colours or tones, 3 bits – eight colours or tones, etc. In general, n bits allows 2^n colours or tones. Twenty four bit (2^{24}) can display a possible 16.7 million colours.

See also **Bit depth**

Bits per second (bps)

See **Baud rate**

Black point

The point on an image **histogram** which defines the darkest point within an image.

Blend modes

The way in which two images are blended together, or the way in which pixels are affected by colour applied using a brush or other **tool**.

The facility within **Photoshop** and other image processing programs to blend two images (or layers, or colours) together in a number of different ways. **Photoshop® CS**, for example, has over 20 blend modes, including 'multiply', – where the value of the pixels in the 'base' image are multiplied by the values of the pixels in the second image (or **paint**) – and 'colour' mode – where the colour being applied to an image is applied in proportion to the value of the underlying pixels, for example, when applying a green colour, a number of shades of grey become green; light grey becomes light green and dark grey becomes dark green. In each blend mode, the effect can be modified by the use of the **opacity** and 'fill' sliders.

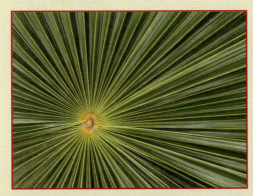
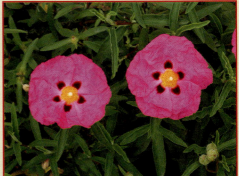

The original (base) image and the blend image.

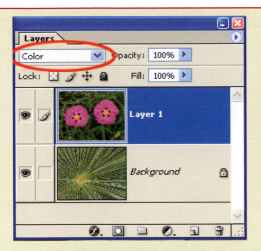

Layers palette in **Photoshop** showing the two images and
location of blend modes.

The blend mode drop down menu.

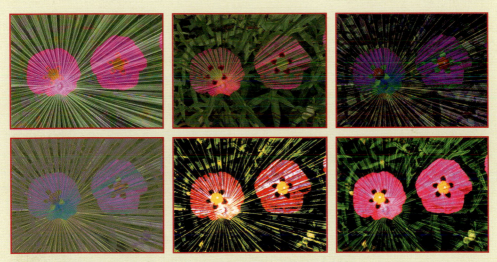

Examples of different blend modes: colour, darken, difference, exclusion, hard mix, vivid light.

Blooming

A problem, mainly with previous generations of **CCD**s that causes pixel level distortions when the electrical charge created exceeds the pixel's storage capacity, and spills into adjacent pixels. It is caused by overexposure of the image, and is particularly noticeable as **halos** or streaks around specular highlights. New CCD designs incorporate **anti-blooming** circuitry to drain the excess charge so that it does not affect adjoining pixels except in extreme lighting situations.

Bluetooth

A standard introduced by various companies including **IBM**®, Nokia® and Toshiba® for wireless, radio-wave communication between different devices. Unlike infrared data transfer, Bluetooth does not require visual contact between the communication devices. It operates on a frequency of 2.4 GHz and offers a regular transfer rate of 1 MBit/s. Its normal range is 10 m.

Blur

Part of an image that is not sharp, either due to out of focus, or the subject being moved during exposure.

BMP (Windows bitmap)

The native format for Microsoft® Paint, a simple **paint** program included with Microsoft® **Windows**®. It is supported by a number of Windows applications and operating systems. BMP images can be saved in 24 bit format, and be used in conjunction with **run length encoding (RLE)**, a **lossless compression** system.

Brightness range

Refers either to the range of brightness (**luminance**) within a subject, or to the potential range of brightness capable of being captured by an imaging system.

Broadband

A high speed (higher **bandwidth**) **Internet** connection, from 256 KBps up to 3 MBps or more.

Browser

The **software** that acts as the translator for **digital** data, and turns it into readable **Internet** pages. Examples are NetScape®, and Microsoft Internet Explorer.
See **File Browser**

Bubble jet printer

See **Ink-jet printer**

Buffer

An area of memory in a computer or **peripheral** device such as a camera or printer, either as RAM, a separate **cache**, or **hard disc** set aside to undertake a specific function. The **printer buffer**, for example, will store the information to be printed, thus freeing the **CPU** for other tasks.

Bug

A fault, or logic error, in a computer program which may cause either the program to fail or the computer to 'crash', or cause some feature not to work correctly. Before new programs are released onto the market, testers are supplied with **beta versions** to try and find any bugs. Due to the complexity of modern computer programs it is almost impossible for **software** writers to test all possible combinations that users might conceivably use.

Burn

1. To record a **CD** or **DVD**
2. Traditionally, a darkroom term where an area of the print is given more exposure, or 'burned in', usually through a hole in an opaque object held in front of the print during exposure. Burn **tools** are found in image processing programs such as **Photoshop**.

Burst mode

The facility within **digital cameras** of taking a number of shots in quick succession (up to eight **frames** per second in some **DSLR** models). The limit to the total number of shots which can be taken in one burst is the size of the **buffer**, which is used to store the images whilst they are written to the memory card.

Bus

A conducting pathway composed of thin metallic wires along which data travels as electric signals to various parts of the computer. A typical computer will contain several buses of different types.

Byte

The standard unit of **binary** data storage in computer memory or disc files. A byte containing 8 **bits** can have any value between zero and 255 (2^8).
One Kilobyte (KB) = 1024 bytes
One Megabyte (MB) = 1024 KB (1 048 576 bytes)
One Gigabyte (GB) = 1024 MB (1 048 576 KB)
Strictly, the term 'kilo' refers to 1000, but is used here for 1024, etc., because of the binary system used).

16

Cc

Cache

High speed memory chips which store frequently used instructions. This is much faster than using conventional **RAM**.

Calculations

The facility within programs such as **Photoshop** to add two images together, multiply them or view the differences between them.

Calibration

Restoring a device such as a printer to a specified condition.

Card reader

A device for downloading images from **digital camera memory cards** into a computer. Multiformat versions are available that can read several different types of cards.

Cast

An unwanted, overall predominance of one colour in an image.

Cathode ray tube

See **CRT**

CCD (charge coupled device)

See **Image sensors**

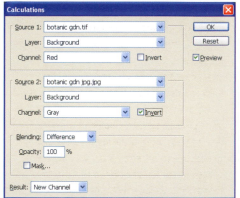

Calculations: The difference between a **RAW** image and a **JPEG** compressed version of it, obtained by using the 'calculations' command in **Adobe Photoshop**.

CCD element pitch

The distance between the centres of two adjacent pixels in a **CCD**. Modern CCDs vary between 5 and 25 μm.

CCITT (Comité Consultatif Internationale de Télégraphie et Téléphonie)

A lossless form of **data compression** mainly used for black and white images. It is supported by **EPS** and **PDF** formats.

CEPS (colour electronic prepress systems)

An image manipulation and page layout system used in the graphic arts industry.

CFA (colour filter array)

The pattern of coloured **filters** overlaid on the picture elements of a **CCD**.
See **Bayer array**

CD (compact disc)

A 120 mm (4.75 in.) circular plastic disc, 1.2 mm thick, used for storing **digital** data. A layer of highly reflective aluminium is sandwiched between a layer of clear polycarbonate plastic and a lacquer coating, to prevent scratching as well as oxidation of the aluminium. The surface of the reflective layer is known as the land, and data is recorded by stamping minute indentations into it called pits. The data is recorded along an extremely thin spiral track (approximately 1/100th the thickness of a human hair) which if straightened would be around 5 km long. This track spirals from the centre of the disc outwards, and is divided into sectors, each of which is the same physical size. The motor which spins the disc employs a technique known as **constant linear velocity**, whereby the disc drive motor constantly varies the speed of spin so that as the detector moves towards the centre of the disc, the rate of spin slows down.

To read the data, a laser beam is focussed onto the aluminium layer through the bottom surface of the disc. As light is reflected off the surface, variations in the reflected light are interpreted as 'zeros' and 'ones', **binary** data, which is fed to the computer or microprocessor.

A standard CD can hold up to 650 MB of data. There are many different formats available, according to the type of data stored. These formats are defined by a set of standards known as the **Colour Book standards**.

CD-Bridge

CD-Bridge was introduced to allow the creation of CDs that were both **CD-ROM XA** and **CD-I** compatible. It added the extra information required for CD ROM XA onto a CD-I disc.

CD-DA (compact disc digital audio)

Compact disc format used only for sound data, and capable of holding approximately 74 min of audio data. The standard is defined by the 'Red Book'. The data is compressed, and encoded using error detection and error correction code **(ED/ECC)** to ensure the highest possible sound quality.

CD-E (compact disc erasable)

A compact disc that can be recorded and erased.

CD-I (compact disc interactive)

A version of the compact disc carrying text, audio and video for interactive uses, defined by the 'Green Book' standard.

CD-ROM (compact disc read only memory)

The term is often used to describe any compact disc, but is strictly defined by the 'Yellow Book' standard to define additions to the CD-DA format to make them readable by computer.

18 **CD ROM XA** (eXtended architecture)

System using a standard similar to the CD ROM, but with some additional features for video and audio.

CD-R (compact disc recordable)

A recordable (only once) CD disk (*see* **WORM**).

CD-RW (compact disc rewritable)

Compact disc that can be re-written around 1000 times. Besides the standard size of 12 cm diameter, smaller versions of 8 cm are also available.

CD-WO (compact disc, write once)

A compact disc that is only playable.

CGM (computer graphics metafile)

An **ANSI file format** for defining both **raster** and **vector graphics** in one file.

Channels

Digital images are composed of channels, which can be viewed and manipulated separately in most image processing programs. Most colour images are composed of three channels, red, green and blue. Programs like **Photoshop** offer the facility of changing the mode of an image, enabling the conversion from **RGB** to four channel **CMYK**, single channel greyscale, or three channel Lab, for example.

It is also possible to apply adjustments and enhancements to single channels if required. For example, noise in a digital image is usually found primarily in the red and blue channels, so it is often best to apply noise reduction **filters** to just those channels. Also, when applying a sharpen filter, it is often good practice to apply it to the L (**luminance**)

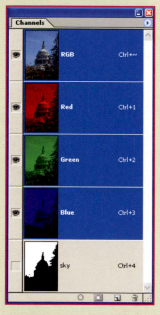

Channels: The 'channels' palette in **Photoshop** for an **RGB** image with an **alpha channel**.

Original image.

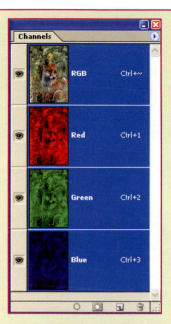

Channels palette in **Photoshop** showing red, green and blue channels for **RGB** mode.

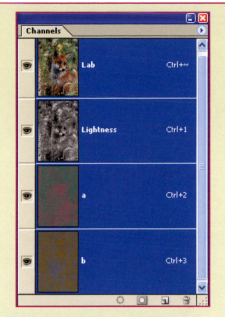

Channels palette in Photoshop showing lightness (luminance), 'a' (green to red) and 'b' (blue to yellow) channels in Lab mode.

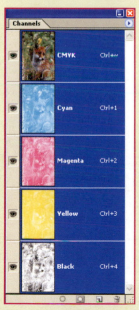

Channels palette in Photoshop showing yellow, magenta, cyan and black channels for **CMYK** mode.

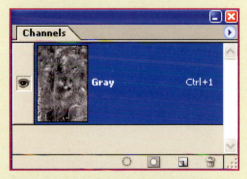

Channels palette in Photoshop showing single 8 bit greyscale channel.

channel only in the Lab mode, to minimize colour **artefacts**.

An extra channel, the '**alpha channel**', can be added to record information relating to selections, masks and other data.

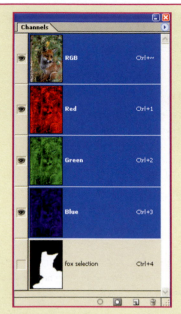

RBG image with **alpha channel**, showing saved selection within image.

Chroma

The saturation, intensity, or purity of a colour. *See* **HSB**

Chromatic aberration

The presence of coloured **halos** around objects, resulting from light of different wavelengths being focussed at different planes within the camera.

Chrominance

The difference between two colours that are equal in brightness.

CID (charge injection device)

An imaging sensor similar to a **CCD**. Unlike the CCD, the CID does not move charges before readout. Instead, the charge on the CID remains stationary, and selective readouts are made from individual pixels. CIDs are particularly good at minimizing **smearing** and **blooming**.

CIE (Commission Internationale de l'Éclairage)

Commission Internationale de l'Éclairage
1. An International group set up to produce colour standards.
2. The name given to a **colour space** model.

CIE *L* a* b*

A three dimensional mapping system used to define the three colour attributes. *L** represents the lightness of a colour, *a** represents the red–green value, and *b** represents the yellow–blue attribute.

CIFF (camera image file format)

An image **file format** now replaced by **DCF**.

Cineon™

A 10 bits per channel **file format** developed by Kodak suitable for electronic compositing, manipulation, and enhancement. The format is used in the Cineon Digital Film System, which transfers images originated on film to the Cineon format and back on to film.

Circle of confusion

The patch of light produced by a lens when it images a distant point source of light. When parts of an image are incorrectly focussed, the overlapping circles of confusion cause a 'blurred' effect. Lenses designed for film cameras can generally resolve image detail between 20 and 30 micrometres (μm), this value being limited by the diameter of circles of confusion produced by the lens aberrations.

When related to imaging with **CCD** sensors, then the circle of confusion produced by a lens should be no larger in diameter than the **CCD element pitch**. Modern CCDs have element pitches ranging between 5 and 25 μm, though some **linear array CCDs** employing a sub-pixel shift system can have a figure of around 3 μm. The lens used must be good enough to produce the high resolution results of which the CCD is capable.

CISC (complex instruction set computer)

A type of computer architecture which sends instructions through different units of the computer, one at a time. It was the system used by Motorola 68000® series of microprocessors used in the original Apple® Macintosh® computers. It has been replaced by chips using **RISC** processors.

Clipboard

A designated part of the computer **RAM** which holds the last item **copied** or **cut** from a file. An item held in the clipboard can be **pasted** into other files.

Clipping

Loss of shadow or highlight detail due to the conversion of grey tones lighter than a certain value to white, or darker than a certain value to black.

Clipping path

A capability of **Postscript** to allow an **EPS** file to contain an irregular border that defines its edges.

If the path has been defined, then points outside will be transparent if it is imported into another application. It is useful for making 'cutouts' of images to drop into white space.

Clock speed

The effective 'speed' at which the **central processing unit (CPU)** in a computer communicates with the various elements within it. The processor runs at a fixed clock speed, regulated by the pulses of a quartz crystal. The speed is rated in megahertz (MHz) – 1 MHz representing one million instructions per second.

Cloning

The selection and duplication of groups of pixels within an image. For example, an area of skin tone can be 'cloned' to hide a skin blemish. The cloning **tool** in most imaging programs can be varied to select different sized areas of pixels to be cloned,

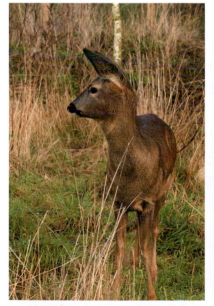
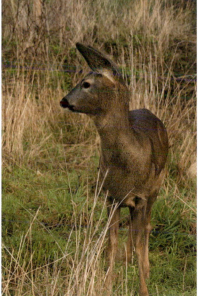

Cloning: An example of pixel cloning to remove unwanted detail from a background. In this case the tree behind the deer has been removed, together with some of the grass stems, by cloning grass from other areas of the image over the tree.

and the manner in which they are cloned such as the **blend mode**.

CLUT (colour look-up table)

See **LUT**

CMOS (complementary metal oxide semiconductor)

An alternative imaging sensor to the **CCD**, which can contain more processing functions in its architecture. It converts the **signal** to a **digital** value within each pixel in a single step. It requires less power than the CCD, and is cheaper to manufacture.

CMM (colour matching module)

Software which interprets information from device profiles, and carries out the instructions on how the colour gamut of each device in the imaging chain should be treated.

CMS (colour management system)

A system used in image processing, desktop publishing and other applications for achieving predictable, consistent and accurate colour rendition from input to **output**. Examples are Apple's **ColorSync**® and Microsoft® **ICM**.

CMYK (cyan, magenta, yellow and black)

The four colours used by printers to produce printed colour illustrations.

Codec (compressor/decompressor) (sometimes coder/decoder)

The process of compressing and decompressing image, video or audio data.

Colour aliasing

Where an object of a certain colour overlaps pixels of different sensitivity, **colour fringing** may occur.

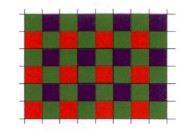

Filtered CCD showing pattern ("Bayer") of filters.

Block of four groups of filtered pixels. When toned or coloured subjects fit exactly within group boundaries, then the colour will be true.

When the coloured subject overlaps two pixel groups, colour aliasing will occur, giving false colours. The pixel group at top right will become a light magneta, whilst the group at bottom right will become light yellow.

Colour Book standards

A set of standards defining the physical format of data recorded onto a variety of **CD ROMs**, e.g., Red Book defines the standards for audio CDs. Other book standards include Yellow Book, Green Book, Orange Book, and White Book. The Book standards do not address the issue of logical **file format** for CD ROMs. This is covered by the **High Sierra Standard**.

Colour difference signals

The two signals (CC) in a **YCC** format which carry the colour information:

red minus luminance

blue minus luminance

green is computed from the remainder.

Colour fringing

An **artefact** in imaging sensors where colour filtering conflicts with information in the subject. *See* **colour aliasing**

Colour gamut

A range of colours that can be captured, displayed or printed by a particular device, specified within a CIE **colour space**.

Colorimeter

An instrument for measuring colour. It measures the relative amounts of red, green and blue in a sample.

Colour management

The term colour management is used to describe the process of calibrating and aligning all devices in an imaging chain, so that the **output**, be it monitor display, ink jet print, or **photomechanical reproduction** in a book or magazine matches the input closely. The main aims are predictability and consistency.

The basic problem is that all devices are different – even the same model of monitor may look different in different environments, or the same model of printer may give different results when attached to different computers, for example.

The basic principle of colour management is to know the characteristics of the various devices within the imaging chain, and communicate these characteristics to all the other devices. Also, the imaging workflow is effectively a destructive process, usually because the final target **colour space** (ink jet print or magazine reproduction, for example,) is smaller than the original colour space. Successful profiling ensures that this destruction of data is kept to a minimum.

There are two basic levels of colour management: closed loop and open loop.

In a closed loop system, photographers have all devices from input to output, under their control, and can relatively calibrate each one easily so that results become predictable.

In an open loop environment, photographers may have control over the input and processing stages, but then hand the images over to a third

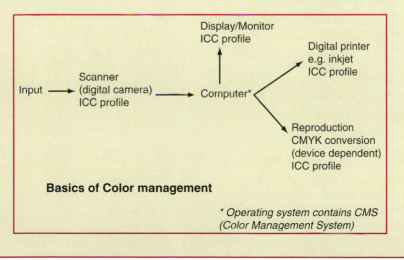

Basics of Color management

** Operating system contains CMS
(Color Management System)*

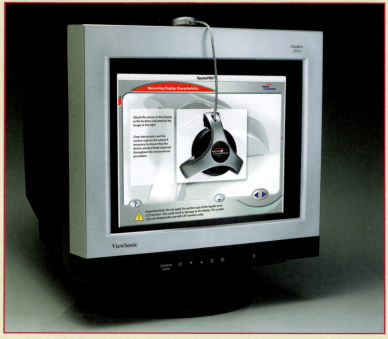

Monitor calibration.

party for output (such as printing in a book or magazine). It is in this scenario that communication between the photographer and designer or printer becomes essential.

A colour management system consists of three basic components:

A device independent colour (working) space
Colour profiles (ICC, **ColorSync**®)
A colour matching module (**CMM**) which interprets the information from device **profiles** and carries out the instructions on how the **colour gamut** of each device in the imaging chain should be treated.

The basis of successful colour management is profiling – understanding the actual characteristics of a device or ink, and communicating this information to the next device in the imaging chain. Profiles may be supplied with a device (generic) or custom made for each specific device such as a **monitor** or printer.

An analogy is the translation of text from one language to another. Translation of all languages into all other languages would require two dictionaries for every combination of languages (English–Chinese, Chinese–English, for example). A much more elegant solution is to create a universal language. Now, only two dictionaries are required per language (English–Universal, Universal–English). With these, we could now translate English–Universal–Chinese. The CIELAB colour space provides this universal translation area. All that now needed is an input CIELAB for all input devices, and CIELAB for each output device. Profiles create a translation between the different colour spaces of various devices.

Colour Management Systems (CMS) are built into both the Apple® Mac OS® (**ColorSync**®) and **Windows**® (ICM) operating systems. The basic idea is that the colour management engine recognizes

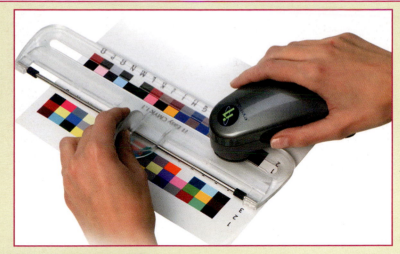

Image densities being measured to produce profile.

the profiles from each device in the workflow, and translates one to the other.

It is relatively easy to produce custom profiles for **scanners**, monitors, and printers such as ink jets. Commercially available software and **hardware** are available to analyse monitor displays or prints.

Industry standard targets (such as IT8, or Macbeth® ColorChecker charts) can be scanned (or photographed) and the resulting densities measured. In the case of printers it will be necessary to produce a profile for each ink and paper combination.

Colour picker

A colour model within an image processing program, displayed on a computer **monitor**, where colours can be selected according to their hue, saturation, and lightness.

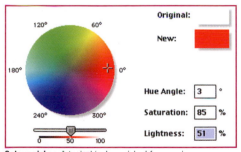

Colour picker: A typical 'colour picker' from an image processing program, showing the settings for hue, saturation and lightness (brightness).

Colour separation

The process of separating an image into its component colours usually for the purpose of photomechanical printing. Four-colour litho printing requires cyan, magenta, yellow, and black separations. The process can be carried out at the time of **scanning**, or during image capture with some **digital cameras**, or using computer **software**.

Colour space

A three-dimensional space or model where the three attributes of colour, hue, saturation, and brightness can be represented, e.g., CIE **Colour Space** and Munsell colour space.

ColorSync®

The **colour management system** built into the Apple Macintosh OS X for ensuring that all devices in an imaging chain communicate with each other with regard to colour characteristics. This capability is made possible by a device registration **database** which automatically registers at least one **profile** for every imaging device when it is first connected to the computer. The profiles in the device registration database can be recognized and used by applications in the **digital** workflow.

Colour temperature

A term referring to the predominant colour of a particular light source. It is measured in degrees Kelvin (K). It is a measure of the relative amounts of red and blue wavelengths in the light source – the redder the light source, the lower the colour temperature. Common examples are:

'photographic' tungsten – 3200 K
electronic flash – 5500 K
HMI lighting – 5600 K
'average daylight' – 5500 K *

(*daylight is extremely variable, ranging from the red/orange light of sunrise/sunset, to dull overcast conditions which may have a colour temperature in excess of 10 000 K).

Colour films are balanced for particular colour temperatures, usually daylight (5500 K) or tungsten (3200 K). **Digital cameras** and video cameras can be '**white balanced**' to give the 'right colour' with different types of light source.

Colour temperature meters are available, which measure the relative amounts of red and blue in a light source.

An alternative way of expressing colour temperature is the **MIRED** (microreciprocal degree) which represents one million divided by the Kelvin value. Daylight of 5500 K corresponds to 182 MIRED. **Filters** for modifying colour temperature are often quoted in MIRED values.

Colour trapping

A printing term referring to the solution with slight mis-registrations in the printing process. If two colours are mis-registered, a white or coloured line will appear around the object. Trapping is the process of adding extra colour to fill in the gap created. Programs such as **Photoshop** have trapping capabilities.

Comb filter

A filter that separates the **chrominance** and **luminance** information in a signal.

Compact camera

A camera type which uses a direct vision rather than a **reflex** viewing system.

CompactFlash®

A type of memory card for **digital cameras**, using non-volatile memory. There are two types differing in their thickness. CFI is 3.3 mm thick, whilst CFII is 5 mm thick. Many digital camera models have slots that will read both types. CFI cards are solid state, with no moving parts, and have maximum capacities up to 8 GB currently, whilst CFII cards are miniature **hard discs**, with a rotating platter and reading arm, and a maximum capacity of 1 GB.

They also vary in their 'speed', with 12*X*, 16*X*, and even 40*X* being available. Strictly, the X = 150 KB per second writing speed (thus a 12*X* card will write data at 1800 KB/s). However, this figure will also be dependent on several factors such as camera model, and **buffer** size.

Composite signal

The television signal that consists of the video signal (**luminance** and **chrominance**), burst signal and sync signal (horizontal and vertical).

Compression

A **digital** process that allows data to be stored or transmitted using lesser than the normal number of

bits. Compression can be **lossless**, **lossy** or
visually lossless. There are several types of which
the **JPEG** standard of lossy compression is widely
used for still imaging. In general, compression
should not be used where images may be required
for scientific analysis for although the data loss
may not be visually apparent, it may be essential
from a scientific or legal point of view.

Constant linear velocity

The motor which spins a compact disc employs a
technique known as 'constant linear velocity',
whereby the disc drive motor constantly varies the
speed of spin so that as the detector moves
towards the centre of the disc, the rate of spin
slows down. This contrasts with magnetic discs,
which spin at a 'constant angular velocity'.

Constrain

To limit the proportions, angles or shape of an
object when it is moved or changed on screen.

Contact sheet

The photographic process of laying down negatives
directly onto photographic paper and making same
size reference prints. For example, in image
processing programs such as **Photoshop**, the
equivalent can be achieved for making **index prints**
from the contents of a folder.

Contone (continuous tone)

An image exhibiting a full range of tone or colour,
without obvious **contouring** or **posterization**. In the
case of **digital** images, greyscale images should have
a minimum of 256 tones (8 bit), whilst with colour
images, each channel of colour information should
be represented by at least 256 possible tones.

Contouring

See **Banding**

Contact sheet: The contact sheet facility in **Adobe Photoshop**.

Contract proof

A colour proof of high quality that printers will
accept it as a guide to show how the final printed
result should look.

Contrast

The relationship between the lightest and darkest
parts of an image.

See **Dynamic range**

28

Convolution

The application of a mathematical process to an image or part of an image. An example is the application of a **kernel** or **filter**.

Coprocessor

Separate processing chips to the main processor, which undertake specific functions, such as mathematically intensive operations. These are often referred to as maths coprocessors or **floating-point coprocessors (FPU)**.

Copy

To make a copy of a selected piece of text or image, store it temporarily in the memory (**clipboard**) of the computer for later '**pasting**' into another file, or part of the same file.

CPU (central processing unit)

The 'brain' of the computer. The CPU controls the flow of data around the computer, using its 'instruction set', and the known locations of memory, registers and input and **output** devices. The performance of the computer is generally determined by the speed at which the CPU can process data, and how fast it can transfer information. A common measure is **MIPS** – millions of instructions per second (or MegaHertz). The speed will also be dependent upon factors such as **buses**, interfaces, amount of memory, etc.

Cromalin®

A page proofing solution produced by the Dupont® company which uses the same technique of generating the four printing separation images **CMYK**. However, the film separations have a laminate applied to the back of each film. The action of exposing the film to ultraviolet light hardens the exposed areas and leaves the unexposed areas with a sticky surface. After each exposure the laminate is passed through a processor containing finely powdered pigment of the appropriate colour which adheres to the surface. After all four layers are assembled, the surface is covered with a protective film and the composite layers are hardened.

Crop marks

Lines, and other symbols, printed around the edges of pages or images, to show where the final page or image should be trimmed.

Crop marks: A print with various crop marks to enable accurate trimming and alignment.

Crosfield® CT (continuous tone)

File format allowing files to be exported directly into Crosfield work stations; now largely redundant.

Cross-platform

A **file format** that allows the transfer of computer data from one computer **platform** to another, e.g. **IBM® PC** to Apple® Macintosh®. A common example is **TIFF**.

CRT (cathode ray tube)

The device which forms the basis of many television and computer **monitor** displays. It consists of an evacuated glass tube with a phosphor screen at one end and electron guns at the other, in which a coil of wire is heated to produce a stream of electrons. The negatively charged electrons are accelerated and focussed to form a beam which strikes the inside of

the screen. This is coated with phosphors which emit light when struck by the electrons. The beam is deflected either by magnets, or electrostatic forces to form a **scanning**, or **raster** pattern on the screen. Typically, the beam moves from left to right, and vertically, until one scan of the screen has been completed. On reaching the bottom of the screen, the beam 'flies back' to the top, but slightly underneath the first, to complete another scan. The two scans (**fields**) are **interlaced** to produce a **frame**.

In colour systems, three electron guns (one for each of the three colours, red, green, and blue) scan the screen and fire a stream of electrons at the screen in proportion to the intensity of the signal received from the **digital** to **analogue** adapter in the computer. This device compares the digital values sent by the computer to a **Look-Up Table** which contains the matching voltage levels needed to create the colour of a single pixel. As the electrons strike the phosphors coated inside the screen, light is emitted. Three different phosphor materials are used for red, green and blue. If a group of **RGB** phosphors is struck by equally intense beams of electrons, the result will be a dot of white light. Different colours are created when the intensity of the beams is varied. The phosphors are coated onto the screen either as narrow closely spaced stripes (the Trinitron system), or as pattern of dots arranged in groups of three (**triads**). Immediately behind the screen is a grill of fine wires known as an aperture mask or **shadow mask**, so designed that the electron beams from the three guns strike the appropriate colour phosphor.
See **Monitor**

CRW

The **RAW file format** generated by **Canon digital cameras**.

Cursor

Symbolic representation of a particular computer **tool** (text, paintbrush cloning tool, etc.) which can be moved around the screen usually by means of the **mouse**. Clicking the mouse button will determine the 'insertion point' – the point on the screen, where the operation will commence. Different programs will have their own cursors for their own specific range of tools, for example **Adobe Photoshop**® has over 40 different cursors.

Curve

A graphical representation of the contrast and colour of an image. Most image processing programs offer the capability of modifying the image using the '**curves**' control. Sometimes it is referred to as 'gamma curve'.

The curves facility in programs such as **Photoshop** is a sophisticated control for controlling the density and contrast of images or selected regions of images.

It operates in a similar way to the characteristic curve for film emulsion, with the horizontal 'x' axis representing the input values, and the vertical 'y' axis representing the **output** values. In general, the steeper the angle of the curve, the higher the contrast of the resulting image.

The curve in an image processing program can be adjusted to alter the overall angle or by placing anchor points (or 'pegs'), specific areas of the image, such as shadows or highlights. Adjustment can be made to the overall brightness and contrast of the image by selecting the **RGB** channel or individual colours by selecting the appropriate channel.

In the example shown, the shadow of the output image has been darkened, whilst the highlight has been lightened. The table shows typical values for highlights and shadows:

	Shadow	¼ tone	Mid tone	¾ tone	High-light
Input	0	64	128	192	255
Output	0	45	128	215	255

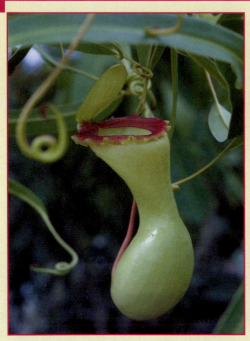

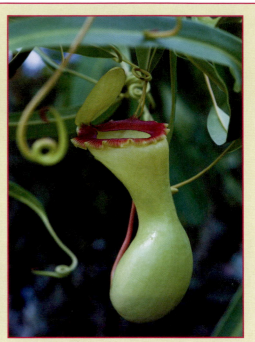

Original image of Pitcher Plant is low contrast and has a blue cast due to the low light level in the glasshouse where it was photographed

Image following curve adjustment – brightness and contrast are much improved but the colour cast remains.

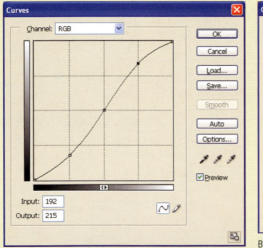

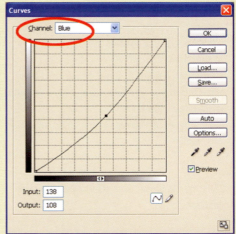

Brightness and contrast enhanced by manipulating the curve into a shallow 'S' shape

Blue cast removed by adjusting the curve for the blue channel only.

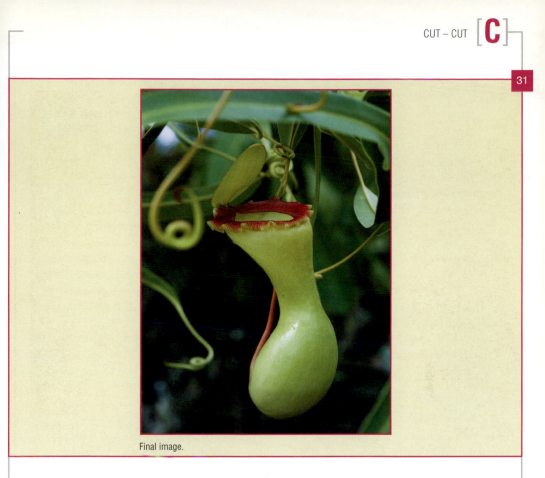

Final image.

Cut

To remove a selected piece of text or image from a file. The cut selection is stored temporarily in the computer memory (**clipboard**), and may later be **pasted** into another file or another part of the same file.

Dd

D50

The CIE Standard light source that represents a **colour temperature** of 5000 K (equal energy daylight), which is widely used in viewing booths and light boxes in the graphic arts industry for assessing print **output**. D50 is the International Standard target white point for viewing prints and is the viewing condition implicit in **ICC** colour management.

D65

The CIE Standard light source that represents a **colour temperature** of 6500 K (average daylight), which is widely used in viewing booths and light boxes in the graphic arts industry for assessing print **output**.

DAC or D/AC (digital to analogue converter)

Circuitry for converting **digital** data into an **analogue** signal, e.g., where digital video is to be **output** to **analogue** video tape.

Dark current

Even when no light falls upon an **imaging sensor**, a small background charge, the dark current (**noise**), builds up in the pixels. When the level of charge induced by light is not significantly higher than the dark current, then image quality may become unacceptable.

In practice, when a **CCD** is operated using an 'open flash' technique, for example, levels of unwanted noise may appear in the image. CCD's designed for scientific use, where long exposures may be required, may be electronically cooled by a 'Peltier element'.

Dark frame

It is possible to remove or minimize the effect of **dark current noise** by shooting a 'dark frame'

immediately after the proper **frame**. This should be taken with the lens cap on, and for the same shutter speed/aperture combination as the original. This frame is then subtracted from the original image using image processing **software** routines such as the **calculations** command in **Photoshop**.

DAT (digital audio tape)

These drives allow the storage of large amounts of information on small cheap tape cartridges. They work on a similar principle to video tape recorders except that the data recorded is **digital** rather than **analogue**. A recording drum with two heads spins at high speed. Tape is moved past the heads at a slight angle to them so that data is written to the tape as narrow diagonal tracks rather than a continuous track along the length of the tape. This increases the usable area of the tape allowing more information to be stored. The format of the data on the tape conforms to the DDS (digital data storage) standard. As well as the raw data, indexing information is included to speed up retrieval of the data. Also, most drives have built-in **hardware compression**. This is much faster than **software compression**. Two types of tapes are available – DDS and DDS-2. DDS tapes are 60 or 90 m long – the 90 m storing approximately 2 GB of uncompressed data. DDS-2 tapes are 120 m long and can store up to 4 GB of uncompressed data, and have faster drive mechanisms. DDS-2 tapes cannot be used in DDS drives. Several sizes are available, such as a single 4 mm wide tape capable of holding 2 GB of data. One problem with all tape systems is that if the information required is in the middle of the tape, the tape must be wound physically to that point. This makes them relatively slow for jumping backward and forward between files, but excellent when recording large amounts of information in a sequential fashion. Whilst the tapes are very cheap and the system is very reliable, the drive units themselves are quite expensive.

Database

A collection of **digital** data which can be arranged in various ways and accessed randomly. Examples are names and addresses, which can be arranged alphabetically, and accessed by surname, town or postcode. Image databases are used for the digital storage and retrieval of images by picture libraries. The success of an image database is dependent on the way that the library or photographer catalogues the collection.

Most use a system of keywords associated with an image. An image of a Badger, for example, might have the following keywords associated with it:

Common name – Badger
Latin name – *Meles meles*
Typical habitat – woodland
Type of animal – mammal
Habits – e.g., nocturnal, omnivore, etc.
Colour – black and white.

Each keyword can be used to search the database. Thus, a researcher might ask to see pictures of

Database: A typical image database (Extensis Portfolio®).

woodland mammals or nocturnal animals, for example. A search can be made using 'either', 'and' and 'or' commands, so that a search can be made for 'mammal' and 'nocturnal', for example, or 'woodland' or 'nocturnal' and 'omnivore'. Such systems usually rely on low resolution '**thumbnails**' which can be viewed on screen, or transmitted to a researcher for selection purposes.

Data compression

Computer data can be compressed in order to reduce the amount of storage space required. There are basically two types of relevance to still imaging, lossy and lossless.

Lossless:

A lossless compression routine is one which does not sacrifice data in the process. This type of compression looks for patterns in strings of bits, and then expresses them more concisely. It uses techniques of **Run Length Encoding (RLE)** to compress the data into a more concise format. An example of Run Length Encoding is used by 'Huffman Compression' which assigns patterns with a code – the most frequently used patterns are assigned the shortest code (this is similar to Morse Code where the commonest letters are assigned

the shortest codes, and the least common the longest, e.g. S = dot, Z = dash, dash, dot, dot). However, because digital documents vary in their type, the Huffman code must create a new set of codes for each document.

For example, the words DIGITAL IMAGE can be processed as follows:

character	frequency
D	1
I	3
G	2
T	1
A	2
L	1
M	1
E	1

This can then be coded as follows:

character	frequency	Huffman Code
I	3	0
A	2	00
G	2	01
D	1	110
E	1	111
L	1	000
M	1	001
T	1	101

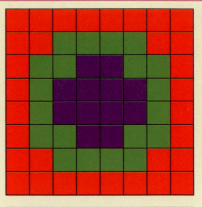

Huffman works best with text files, and variants of it are used in some **FAX** machines. Whilst it does work with images, it requires two passes of the data, the first to analyze the data and build the table, the second to compress the data according to the table. This table must always be stored along with the compressed file. Because of the way Huffman encoding analyzes the data, the process is known as a 'statistical compression method'. A refined version of it which uses a 'dictionary method of compression' is called **LZW** compression – an integral part of the **TIFF** file format.

At the beginning of the file, LZW compiles a small table like the Huffman compression. It then adds to this table every new pattern it finds. The more patterns it finds, the more codes can be substituted for those patterns resulting in greater compression. It does this in one pass resulting in greater speed. LZW can compress images up to 10 : 1.

Another format which uses LZW compression is **GIF**, used by CompuServe for compressing 8 bit images for transferring through networks.

Lossy compression:

A lossy compression routine such as **JPEG** is one which sacrifices data in the process. It relies on the fact that the human eye is much more sensitive to changes in brightness (**luminance**) in an image than to colour (**chrominance**). The image data is separated into luminance and chrominance, and lossy compression algorithms are then applied to

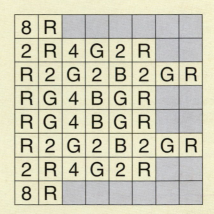

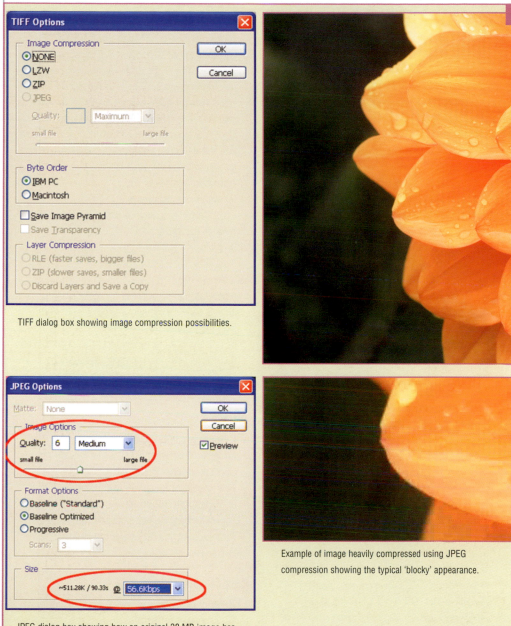

TIFF dialog box showing image compression possibilities.

Example of image heavily compressed using JPEG compression showing the typical 'blocky' appearance.

JPEG dialog box showing how an original 38 MB image has been compressed. Note the sliding scale for quality and size of file, and the final compressed size. Also, the time that it would take to send the image by **modem** (56.6 kbps in this case).

the chrominance data. (This is similar to television, where a medium resolution monochrome signal is overlaid with a low resolution colour signal.)

Users of JPEG have the opportunity to determine the level of compression at the time of saving the file, either in camera or in the computer. In general, the higher the compression, the lower the image quality. Images heavily compressed with JPEG are characterized by a 'blocky' appearance in areas of flat tone. The amount of data lost may or may not be noticeable depending on the final use of the image.

Note: The JPEG process is cumulative, and care should be taken not to apply JPEG compression to an already JPEG'd image.

A new version of JPEG (JPEG 2000) was launched which uses 'wavelet technology', but has not yet been universally adopted.

Data projector

A device for projecting **digital** data from computers. There are basically two types: **DLP (Digital Light Processing)** projectors and **LCD** projectors. (Other types are: **CRT** and **LCOS**, liquid crystal on silicon, which are used on high end projectors, now usually only found in large lecture theatres. They are expensive, and generally difficult to install and maintain.)

LCD types contain three separate LCD glass panels, one each for the red, green and blue components of the image. As the light passes through the LCD panels, individual pixels can be opened to allow the light to pass through, or closed to block the light. LCD projectors tend to give very sharp, highly saturated colours, well suited to graphics presentations. They have two main disadvantages the 'screendoor' or 'chicken wire' effect whereby the pixel structure is visible. In modern LCD video projectors this is much reduced by using higher resolutions and Micro Lens Arrays (MLA) which reduce pixel visibility. Their other main weakness is the low contrast ratio, meaning they cannot usually match the DLP type for colour detail or black **density**.

DLP types use an optical semiconductor known as a Digital Micromirror Device (DMD chip). This has an array of tiny aluminium mirrors on the surface of the chip, each of which represents a single pixel on the screen. Each mirror is hinged and is tilted to deflect light from the lamp, or reflect it through the lens onto the screen as a single pixel. A single chip may have over a million mirrors. The images may have a truer colour than the LCD projector, but they may not be as saturated. The images will be less pixellated than LCD types, and are capable of high contrast, making them well suited to video projection. The projectors tend to be smaller than LCD types, but may occasionally suffer from a 'rainbow' effect – a rainbow-like striping trailing from bright objects.

Data projectors are available in various resolutions, **SVGA**, XGA, SXGA, and different brightness to suit the projection environment.

DCF (Design Rule for Camera File System)

A specification for enabling the direct exchange of images between cameras and other equipment, allowing pictures taken on one camera to be viewed on another, or to be **output** to a printer. To this end it specifies rules for recording, reading and handling image files and other related files used on **digital cameras** and other equipment.

DCS

1. **Desktop colour separation**
An image **file format** consisting of four separate **CMYK PostScript** files at full resolution plus a fifth **EPS** master for placement in documents.
2. **Digital camera system**
The name for the range of Kodak's original **digital camera**, based on the **MegaPixel** imager attached to conventional Nikon® and Canon® cameras.

Default

The settings which a computer program uses unless altered by the user.

Delta error (Delta *E* or ∆*E*)

A mathematical measurement of the difference between two colours. The figure is calculated from

the position of the colours within the Lab **colour space**. A typical viewer can distinguish between two colours that have a difference of 5–6 ΔE, whilst a trained eye can distinguish values of 3–4. A typical **ink jet printer** may be able to reproduce colours within ±2–4.

Demosaicing

The name given to the processes performed by the **RAW** converter **software** when converting RAW camera data into an **RGB** image.

Density

A measure of the light absorbing properties of items such as **filters**, **pigments**, and photographic images. It is defined as the logarithm of the **opacity** (O), opacity being the reciprocal of transmission (T)

$$D = \log O = \log 1/T$$

For example, if 10 units of light fall on an area of film, and 5 are transmitted by it, then the transmission is 50% or 0.5. The opacity is 2 and the density 0.3.

The densest and least dense areas are known as D_{max} and D_{min}. The difference between the two is the **density range** or **dynamic range**.

Density range

The difference between the values of the densities of the lightest and darkest parts of an image.

Densitometer

A device used to measure the **opacity** of film (transmission) or reflectivity of paper (reflection). Image processing programs such as **Photoshop** have the equivalent of a densitometer (the 'info' dialog box) where the brightness, colour values, and address of individual pixels can be determined.

Depth of field

The amount of a subject, both in front of and behind the main point of focus, which is acceptably sharp. It is determined by the aperture used, the magnification of the subject, and the acceptable value of the circle of confusion.

Depth of focus

The distance through which the film or sensor plane can be moved whilst the image remains in acceptably sharp focus. Mainly relevant to cameras where the film plane can be adjusted, e.g., large format 'technical' cameras.

Desaturate

A command within **Photoshop** and other programs for removing the colour from an image leaving shades of grey.

De-screen

A filter, often built into **scanner software**, for removing or minimizing the effects of the dot screen of a printed image when scanned.

Despeckle

A **filter** within many image processing programs that eliminates randomness in an image. It tends to soften the appearance of an image.

Device dependent

A system where the colour of a file is dependent upon the final device, such as a printing press. For example, the **CMYK** process is device dependent.

Device independent

A **colour management system** which controls the input and **output** of colour independently of the computer system being used.

Dialog box

A box which appears on screen following a command from the user, allowing the user to control or execute instructions.

DIB (device independent bitmap)

An image **file format** sometimes used in multimedia work which allows either the use of **indexed colour**, or 24 bit colour files.

Dichroic filters

See **Interference filter**

Dichroic mirror

A type of **interference filter** which reflects a specific part of the spectrum, and transmits the rest. They are found in **scanners** to split light precisely into three components, red, green and blue.

Differencing

An operation whereby one image is subtracted pixel by pixel from another. The technique may be used in scientific and technical applications to show differences in scenes over a period of time.

See **Calculations**

Diffusion dithering

A method of applying a random pattern of dots to reduce **banding** and other **artefacts** in images.

See **Dithering**, **Error diffusion**

Digital

A signal that represents changes as a series of individual values rather than the infinitely variable **analogue** signal.

Digital camera

A camera that uses a **CCD**, **CMOS** or other type of light sensitive **imaging sensor** rather than silver-based film to record images. They may either consist of conventional film cameras, where the sensor is placed in the film plane, replacing the film, or be purpose designed cameras. Two main types of sensors are found, **area** or **matrix array CCD** or **CMOS** sensors, or **linear array CCDs**.

Types of digital cameras:

There are several different types of digital camera on the market today. The types most applicable to professional photographers are:

'Compact'

Single lens reflex (DSLR)

Digital backs (single shot and scanning backs)

Compact types of camera use a direct vision type of viewfinder, where the subject is viewed through a different lens from the one which actually captures the image. Compact cameras generally use an interline transfer CCD, which enables a live video signal to be seen on the **LCD** display. This reduces the problem of parallax found with film cameras of similar design. Several models, offer a 'movie mode', allowing several seconds of moving image to be shot, with accompanying sound. Another feature sometimes included is the ability to 'stitch' together a series of overlapping images to produce a **panoramic** image.

There are two main types of single lens reflex design, those with, and those without the ability to change lenses. Dust is a major issue with imaging sensors, and having a fixed, non-removable lens ensures that the sensor remains dust free. It is, however, much less flexible than a model with interchangeable lenses. Digital single lens reflex cameras increasingly use **CMOS** sensors.

Digital backs are available as attachments for medium and large format film cameras, taking the place of the interchangeable film holder. These can either be single shot (sometimes with a multi-shot facility), or **scanning** type, where a **linear array CCD** scans the image projected by the lens.

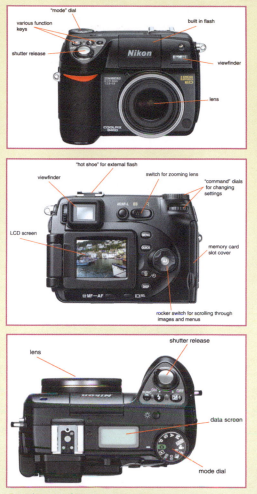

Typical 'compact' digital camera with some of the features labelled.

Typical digital **SLR** with interchangeable lens.

A typical single shot back, such as the Phase One P25, designed to be attached to a 6 × 4.5 cm film camera has a CCD 48.9 × 36.7 mm in size, and has 22 million pixels.

As the name implies, a **scan back** effectively places a high resolution scanner in the image plane. Very high resolutions are possible, a typical model might have 10 000 × 8000 pixels or more. They are limited to still life shots, and require specialist

Typical 'digital back' attached to a medium format film camera body. This particular model has a sensor 48.9 × 36.7 mm in size containing 22 million pixels.

flicker free continuous light sources, such as **HMI** to prevent interference patterns on the image.

Features:

Most digital cameras will have several features in common, such as a range of exposure modes (Program, Shutter Priority, **Aperture Priority**, Manual), and various light balancing facilities, including auto white balance and settings for tungsten, fluorescent and other light sources.

Most will offer the option of saving files either as **JPEG** or **TIFF** (compressed or uncompressed) file format, with many offering a **RAW** format as well. The option is often given too for choosing the number of pixels in an image. For example, a 6 million pixel camera has 3008 × 2000 pixels in total. However, the user might be able to select images with 2240 × 1488, or 1504 × 1000 if the images are not needed at full resolution – for web use, for example.

All digital cameras have an LCD screen for previewing images, either at **full frame**, or as **thumbnails**. Images can be deleted from the camera before transferring to a computer, and placed in separate folders for easier sorting. The LCD can often display the image **histogram**, which can be used for checking exposure and contrast of the image.

Digital lens

A lens for an interchangeable lens SLR type **digital camera** designed specifically for the characteristics of **CCD**/**CMOS** imaging sensors. They are generally of **telecentric** design, where the rays of light strike the surface of the sensor at a steeper angle than those of lenses designed for film. The surface coatings are also designed to reduce unwanted reflection effects such as flare from the surface of the imaging sensor. They may cause shading effects if used within a film camera of different format.

Digital lens: A lens designed for an **imaging sensor** needs to have the rays of light exiting the lens at a narrower angle than for film due to the depth of the wells in the photosites, and the microlenses over each pixel.

Digital zoom

A non-optical facility found within some **digital cameras** for zooming into the centre of an image and interpolating the data to increase resolution. The results may not be as good as optical zoom lenses.

Digi-scoping

The name given to the technique of attaching a **digital camera** to a telescope (typically by birdwatchers), or microscope for recording images.

Digi-scoping: A "compact" type digital camera attached to a birdwatchers' telescope

Digitize

Convert into **digital** form. Digitization is subdivided into the processes of **sampling** the **analogue** signal at a moment in time, quantizing the sample (allocating it a numerical value) and coding the number in **binary** form. A digital image is made up of a grid of points. There is no continuous variation of colour or brightness. Each point on the grid has a specific value. Digital images are recorded as data and not as a signal.

Digitizing tablet

A flat plate, usually A5 or A4 in size, where drawing and pointing operations are carried out with a stylus, which looks and acts very much like a pen. Much finer control over drawing or making selections is possible with the stylus, which is usually pressure sensitive. When using programs such as **Adobe Photoshop**® or **Illustrator**®, the more pressure that is applied to the stylus, the more '**paint**' is applied. Unlike the **mouse** which can be raised, and moved to another part of the mat without altering the position of the **cursor** on

the screen, the positioning of the **stylus** on the tablet dictates the position of the cursor.

DIMM (Dual In-Line Memory Module)

A modern version of the **SIMM** used to increase the RAM of a computer.

DIP

1. **Digital image processing**
See **Image processing**
2. **Document image processing**
The technologies associated with the **scanning**, enhancement and storage of documents, particularly those composed primarily of text, which are often scanned using **Optical Character Recognition (OCR) software**.

Direct to plate

Direct exposure of **digital** data onto printing plates without the intermediate film stages.

Direct to press

Direct transfer of **digital** data onto printing cylinders in printing press without the intermediate stages of film and printing plates.

Direct vision

Type of camera optical viewfinder, where the subject is viewed directly, rather than through a **reflex** system. Typically found in compact types of camera.

DOS (Disc Operating System)

The name of the operating system for Intel® based PCs. More correctly, it should be referred to as MS-DOS® (Microsoft Disc Operating System).

Discrete sampling

The process of taking separate samples and quantizing them to produce a **digital** representation of an **analogue** image.

Dithering

A method for making digitized images appear smoother using alternate colours in a pattern to produce a new perceived colour, e.g., displaying an alternate pattern of black and white pixels produces grey, and an alternate pattern of cyan and yellow produces green. Also widely used as a reference to

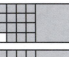

0	8	2	10
12	4	14	6
3	11	1	9
15	7	13	5

Because the printer can only print a single size dot it creates tones by filling in a matrix of 16 dots.
The lightest will have a dot in number 0, a 50% tone will have dots in all numbers up to 8.

Illustration of a 4 X 4 cell to represent 17 tones

the process of converting greyscale data to **bitmap** data, and thus to a reduced grey tone content.

There are two basic types of **dithering** – pattern dithering and **diffusion dithering**.

DLP (digital light processing)

See **Data projector**

D_{max}

The maximum **density** a print or other recording medium can achieve.

D_{min}

The minimum **density** a print or other recording medium can achieve.

DNG (digital negative)

A format introduced in 2004 by Adobe® for the archiving of **RAW digital camera** files.

Docking station

A device which can be connected to a **PC** via the **USB** socket. It contains a socket into which a **digital camera** can be placed to enable easy downloading of image files into the PC. The device may also re-charge the camera batteries at the same time.

Dodge

Traditionally a darkroom term where an area of the print is given less exposure, or 'dodged', usually by means of an opaque object held in front of the print during exposure under the enlarger. Dodge **tools** are found in image processing programs such as **Photoshop** to reduce **density** in certain areas of the image.

Domain name

A unique alphabetic representation of the location of a particular computer within a network.

Dot

The individual element of a **halftone**.

Dot gain

The increase in the size of the **halftone** dot when it is printed onto paper with ink. The effect is caused by the ink spreading into the paper fibres, and the pressure of the rollers used to apply the ink.

Dot matrix

A type of computer printer using an array of pins (usually 9 or 24) which impact onto a ribbon, thus transferring ink onto the paper. The pattern of the dots gives the formation of the character – the more dots used, the better will be the quality. Twenty four pin systems are sometimes referred to as 'Near Letter Quality' (NLQ). They are not usually used for printing **digital** images.

Dot pitch

The physical distance between the holes in a shadow mask on a computer **monitor**. Typical values are 0.2–0.3 mm. The closer the holes, the sharper the image will appear.

Dots per inch

The measurement of a printer's resolution – the maximum number of dots that can be printed per inch of page, e.g., 300 dpi.

Download

To obtain **digital** data such as images or programs from the **Internet**, or transfer image data from **digital camera** memory cards to computers.

Downsampling

To reduce the resolution of an image.

DPOF (digital print order format)

A format which allows the user of a **digital camera** to define which captured images on the storage card are to be printed together with information on

the number of copies or other image information. It usually consists of a set of text files in a special directory on the storage card. The option can be assessed through one of the menu modes on the camera. The storage card can then be taken to a print shop or **output** through compatible desktop printers at home.

Drag and drop

To drag a file onto a program **icon** and drop it, where it will automatically open or print.

DRAM (dynamic RAM)

The type of memory chips used in most desktop computers. They are called dynamic memory, or **volatile memory**, because their contents are constantly changing, and they require an electronic signal – a refresh signal, to enable them to retain their contents. Data is lost when the power is turned off. DRAM chips are arranged in groups on circuit boards called Single Inline Memory Modules.

(SIMMS).

Driver

Software which controls an input or **output** device such as a **scanner** or printer. *See* **Plug-in**

Drum scanner

A 'high-end' **scanning** device for transparency, negative or print originals. Most drum scanners use xenon, or tungsten halogen light sources, which are focussed onto the original to be scanned by a series of condenser lenses. Transparency material, reflective prints or artwork are taped to the outside of a perspex drum, which rotates at 1000 revolutions per minute (rpm). Transparencies are lit from the inside of the drum, reflective materials from the outside. As the drum rotates, a unit containing three photo-multiplier tubes (PMT)

travels across the surface of the drum, thus 'scanning' the original. Three PMT tubes are usually used, one for each of the three primary colours, red, green and blue. A fourth is sometimes used to provide image sharpening information, though this is usually accomplished with **software** nowadays.

Drum scanners have a higher **dynamic range** than **flatbed** or **film scanners**, as high as 4.0 and are capable of higher resolutions. They are much more expensive and complex to use.

DSLR (Digital Single Lens Reflex Camera)

The name given to **digital** single lens **reflex** cameras, usually with interchangeable lenses.

DSU (Digital Storage Unit)

The name given to the storage device used with the world's first **digital camera**, the Kodak DCS 100®, introduced in 1990. The storage unit contained a **hard disc**, a small LCD display screen for 'in the field' editing, and transmission facilities for sending images via telephone lines. It was aimed primarily at the photo-journalist.

DTP (desktop publishing)

The bringing together of various elements such as text, graphics and photographic images into an overall design concept, which can be **output** as one integrated package. Computer programs such as **Adobe InDesign®**, and **QuarkXpress®** are industry standard desktop publishing programs for desktop computers.

Duotone

A greyscale image printed with two colours of ink to give effects such as sepia or copper toning. Programs such as **Photoshop** also have the option for **tritone** (three ink) and **quadtone** (four ink) images.

Duotone: An image converted to duotone mode in **Adobe Photoshop**.

DVD (digital versatile disc)

A high capacity storage system for **digital** data. Currently there are several types and standards.

DVD-R (DVD recordable)

Discs similar to DVD ROM but recordable once. There are two basic types, 4.7 GB single sided, and 9.4 GB double sided.

There are two basic types of drives and media: DVD-R for Authoring is used when the disc is required as a master for later duplication. This is referred to as the Cutting Master Format (CMF), which supports region codes and copy protection. DVD-R for General is appropriate for making small numbers of copies without region codes. The correct media must be used in the appropriate drive, either DVD-R for General or DVD-R for Authoring compatible drives are available.

DVD+R (DVD recordable)

DVDs that can be written once by the user, in the 4.75 GB capacity. They can be played in set-top DVD players and DVD drives in computers.

DVD RAM (DVD random access memory)

A DVD that can be re-written many times. They are available in capacities of 2.6 or 4.7 GB for single sided discs, and 5.2 or 9.4 GB for double sided discs. They cannot be used in set-top DVD players or computers fitted with DVD ROM drives.

DVD ROM (DVD read only memory)

A read only storage disc, similar in size to a CD ROM, but storing information at a much higher **density**. There are currently four different formats:

 DVD-5: 4.75 GB capacity. Stores data on one side of the disc in one layer

 DVD-9: 4.75 GB capacity. Stores data on one side of the disc in two layers

 DVD-10: Stores data on two sides of the disc in one layer

 DVD-18: Stores data on two sides of the disc in two layers.

A crucial difference between the formats is based on which manufacturers support the format.

DVD-RW (DVD re-recordable)

A re-recordable format, where the data can be erased and recorded over numerous times without damaging the medium.

DVD+RW (DVD rewritable)

A re-recordable format, where the data can be erased and recorded over numerous times without damaging the medium.

DXF

A graphic **file format** developed for CAD (Computer Aided Design) systems.

Dye diffusion

An alternative term for **thermal dye sublimation printers**.

Dye sublimation

A type of thermal printer giving nearly photographic quality prints, whereby dyes are transferred onto the paper (or film) in succession. *See* **Thermal dye sublimation printer**

Dynamic effects

Image processing procedures including *flipping*, *rotating*, *distorting* and *sizing* of images.

Dynamic range

A measurement of the possible range of **luminance** recorded by an **imaging sensor** or other imaging system. It is measured either as a logarithmic figure ratio, or as a range of *f*-numbers.

Image **density** is measured with a **densitometer**, on a logarithmic scale where 0 is pure white and 4.0 is pure black. A density of 2.0 has 10 times lesser intensity than a density of 1.0, for example. An intensity range of 100 : 1 has a density range of 2.0, or around six *f*-numbers and 1000 : 1 is a range of 3.0, or 10 *f*-numbers.

The minimum and maximum values of density capable of being captured by an imaging device are known as the D_{min} and D_{max}. If a **scanner** has a D_{min} of 0.2 and D_{max} of 3.1, for example, the resulting **dynamic range** is 2.9. A typical colour transparency may have a dynamic range of 3.5 or more, so a scanner will need to have the capability of recording this wide range of tones, particularly in the shadows (D_{max}) where the D_{max} value might achieve a value of 4.0. A typical photographic print on the other hand might only have a dynamic range of 2.0.

Ee

ECS (electronic image capture system)

A camera that contains a **CCD** or **CMOS** imaging sensor, and records images digitally.

Edge detection

A filtering technique often used in scientific image analysis (but also for creative purposes) where a continuous tone image is converted to a **binary** image, with a white background, and black outlines representing edges in the original image.

Edge effect

A term used to describe a range of effects which perform some manipulation of edges within images.

Edge enhancement

A filtering technique in image processing programs for increasing edge detail in images.

EDO DRAM (extended data out dynamic random access memory)

A type of memory chip with very fast access time.

Effective focal length

See **Equivalent focal length**

Effective pixels

The actual number of pixels involved in the recording of an image. For example, the Nikon D100® **DSLR** camera has 3110×2030 pixels in total (6.31 million) but an effective 3026×2018 (6.11 million pixels) used in actual image production.

EGA (enhanced graphics adapter)

A standard that specifies 640×350 pixels with 16 colour capability from a palette of 64 colours.

Email (electronic mail)

Messages, usually text only, sent from one person to another via computer. Email messages can be sent to groups of people, and have other files, such as images, attached to them.

See **Attachment**

EPI (elements per inch)

A measure of **output** device resolution. The number of exposing (**sampling**) elements in 1 in.

Electro-magnetic spectrum

The range of electro-magnetic radiation arranged in order of decreasing wavelength, from long wave radio to short wavelength X-ray and gamma rays. Some examples of particular relevance to photography and **digital** imaging are:

Type of radiation	Approximate wavelength (in nanometres – nm)
infrared radiation	700–900
red	650–700
orange	600–650
yellow	580–600
green	500–580
blue	450–500
violet	400–450
ultraviolet radiation	10–400

Electron beam recording

A method of recording the signals carried by a modulated electron beam onto photographic material.

Electronic still photography

A term used generally to describe the first electronic images from **analogue** still video cameras.

48

Encryption

To place hidden (or visible) codes within documents, primarily to deter theft. With **digital** images, a digital 'watermark' can be placed in an image to deter copying, or invisible codes can be 'encrypted' into the image. Various systems have been developed over the years, including **PhotoCD** which offered the facility of watermarking. **Adobe Photoshop**® offers the facility through a plug in filter, Digimarc®, for which an annual fee is payable to obtain a user ID.

Enhanced graphics adapter

See **EGA**

Enhancement

The improvement to the brightness, contrast or colour of an image.

EPSF (encapsulated PostScript format)

Refers to a standardized disc **file format** used widely in desktop publishing **software**. It is a file containing **PostScript** commands, with additional data to enable it to be incorporated in other documents. The main data is 'encapsulated' by these additional commands.

Equalize

A command in image processing programs such as **Photoshop**, where the lightest value of an image is converted, or mapped to white, and the darkest tone of the image is mapped to black. The remaining colours or tones are then distributed evenly between these two points.

Equivalent focal length

The effective focal length of a lens on a **digital camera** when compared (usually) to a 35 mm film camera. If the **imaging sensor** is smaller than 35 mm size there will be a magnifying effect.

See **Focal length**

ERI-JPEG (extended range imaging technology)

A proprietary technology developed by Kodak for its range of **DSLR** cameras. The **JPEG** files are captured with raw **dynamic range** and **colour gamut** information, usually discarded by conventional JPEG files.

Error diffusion

The method of placing ink dots in a random pattern (or **dithering** method) in **digital** continuous-tone printers so that the final image, printed with only black ink, looks like a greyscale image. It is used for colour documents too and excellent colour depth and subtle gradation can be achieved.

ESC (electronic still camera)

A camera that contains a **CCD** or **CMOS** imaging sensor, and records images electronically.

Ethernet

A common way of networking computers in a **Local Area Network (LAN)**. Ethernet can handle about 10 million bits per second, and can be used by almost any computer system.

EVF (electronic viewfinder)

The electronic viewfinder consists of a small **LCD**, which displays the picture seen through the lens, similar to an SLR type camera. This is achieved with the help of the **CCD** which continually sends the captured image information to the viewfinder.

EXIF (exchangeable image format)

A type of metadata for recording shooting data from **digital cameras** such as exposure mode, white balance and flash settings. Compatible printers can apply EXIF data to produce optimal printed results.

Export module

The facility to send data to other programs or to an **output** device. Many printers are supplied with 'export modules' – small pieces of **software** ('**plug-ins**') which allow the user to send the data directly to the printer. Also, 'paths' created in programs such as **Photoshop** can be exported to programs such as **Adobe Illustrator**®.

Extract

Facility within **Photoshop** and other programs for masking objects within images for removing backgrounds, for example.

Extreme digital card

See **xD card**

49

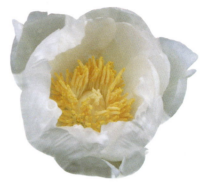

Extract: A facility in image processing programs to cut out an object from its background.

Ff

Facsimile

See **FAX**

FAQ (frequently asked questions)

Documents that list and answer commonly asked questions. Most manufacturers, newsgroups and other **Internet** sites have specific pages to deal with these so as not to clog the system with simple questions.

FAT (File Allocation Table)

A system used by the computer **operating system** to maintain a record of where files are stored on a **hard disc**.

FAX (Facsimile)

The electronic transmission of printed material from one location to another using telephone lines.

Feathering

The softening or 'feathering' of the edges of selected areas of images to help blend them when combined with other images, for example.

FFT (full frame transfer)

See **Full frame CCD**

Field

Half of a video picture composed either of the odd or even line scans which interlace to form a complete **frame**.

Field frequency

The frequency at which two **fields** are interlaced together to make a single **frame**. With **PAL** television systems, the field frequency is 50 fields per second, with **NTSC**, 60 per second.

File browser

A facility within imaging programs such as **Photoshop** for viewing low resolution, **thumbnail** versions of images, before opening them at full resolution. Many file browsers can also display **metadata** and other information.

File extension

The three letter suffix following a dot after a file name to indicate file type (e.g. .tif). There are many hundreds in use for computing. Common ones used in **digital** imaging are: .jpg, .psd, .eps, .pdf, .tif.

Feather: The ability within image processing programs to soften the edges of selections to help blending, for example.

File browser: The facility in **Photoshop** and other programs to preview images as well as the metadata associated with them, before opening them.

File format

The overall format in which any **digital** file is saved. Choosing the correct format for saving images is important to ensure that the files are compatible with various **software** packages. Some formats compress the data for storage. Examples of image **file formats** are: **TIFF**, **EPS**, **RAW**. Most file formats consist of two parts, the data and the header. The data represents the information created and saved, whilst the header records additional information relating to the properties of the file. On an **IBM PC**, header and data information are stored as a single file, whilst on a **Macintosh**, some of the information is stored separately, in an invisible area known as the 'resource fork'.

File size

May refer to the size of the stored file (compressed or not), or the size of the file opened in an application. Without **compression**, the file size of an image is determined by the formula:
total number of pixels × number of bits per colour
 divided by 8 = total number of bytes
for example: an image has 1200 × 800 pixels = 960 000 pixels
960 000 × (24/8) = 2 880 000 bytes (2.8 MB)

This figure will vary according to the **file format** or **compression** used to save the image, and will depend upon a number of factors such as the amount of detail in the image, the file format (e.g. **TIFF**, **EPS**) and any compression routine used.

The following table gives an indication* of the size of the stored file of a 10 MB **RAW** image saved in a number of different file formats:

Photoshop (CS) PSD	10 MB
TIFF with LZW compression:	6.31 MB
JPEG: 'low' quality setting:	212 KB
JPEG: 'medium' quality setting:	572 KB
JPEG: 'maximum' quality setting:	1.1 MB
EPS:	17.9 MB

*The actual size of the file when compressed will depend upon the image content, i.e. whether it contains fine detail or large areas of flat colour.

Fill

A selected part of an image is 'filled' with a colour or tone.

Fill factor

The percentage area of the individual pixel on a **CCD** or **CMOS** sensor given that is active in light gathering. Typically, full frame CCDs have a fill factor of 90%, making them highly efficient, whereas the figure for interline systems is usually much lower around 30%.

Film recorder

A device for outputting **digital** images onto photographic film. There are basically two types: **analogue** and **digital**:

Analogue film recorders use a **cathode ray tube** onto which the image is projected. Three successive exposures are made by a camera system one for each of the three primary colours. This system can be regarded as the automated version of photographing the computer **monitor** in a darkroom using a convention camera system.

52

Resolution is always dictated by the resolution of the **CRT** display. Normally using 35 mm film, this type of recorder is primarily aimed at the presentation market.

Digital film recorders use a **laser**, or light emitting diodes (LEDs) to 'draw' the image onto the surface of the film. The resolution can be increased by controlling the dot that forms the image and the number of pixels it draws to form the image. The system is designed to recreate large format transparencies from images retouched on high end systems. The size of files needed to generate a film image is very large. A 5×4 in. transparency would typically require 60 MB of data. It is also possible to produce negatives, which can then be printed onto photographic paper.

Film recorders depart from convention by expressing their resolution in 'K' rather than dots per inch. K (kilo.) refers to the number 1024, meaning the **addressability** of the system. Typical values are $2K$, $4K$ and $8K$.

Film scanner

Film originals can be scanned using a **drum scanner**, **flatbed scanner** with a transparency adapter or a purpose built film scanner.

Film scanners typically scan only 35 mm or medium format film. They use two methods – **linear array CCDs** and **area array CCDs**:

With the linear array sensor, a single row of **picture elements** is moved across the surface of the film using stepper motors. The physical resolution is dependent on the number of cells in the array and the accuracy of the motor. Resolution is increased by reducing the distance moved by the stepper motors between samples.

The colour information is recorded either by a three pass system once for each of red, green and blue elements of each pixel or by a filter coating on a tri-linear CCD surface to record colour in a single pass.

In the area array CCD, three consecutive images are captured using red, green and blue light. Although generally more expensive, this system produces much better results and is quicker than the linear sensor method. Physical resolution can be increased by moving the sensor a half pixel distance and combining two sets of the three colour images.

Film scanners generally are capable of high resolution and high **dynamic range**. A good scanner dedicated for 35 mm originals will typically have a resolution of at least 4000 dpi, which will yield a file size of approximately 72 MB. It may have a quoted dynamic range in excess of 4.0.

Filmstrip

A **file format** designed specifically for exporting lengths of **digital** video, e.g. exporting **QuickTime™** movies from **Adobe Premiere®** into **Adobe Photoshop®**. Individual **frames** can be edited, and then exported back into Premiere for further editing.

Filter

1. A **software** routine which modifies the characteristics of an image by changing the values of certain pixels. Examples are sharpening, blurring and distortion filters.

2. A transparent sheet of flat, usually coloured, material placed in a light path to selectively absorb certain wavelengths of light from the light path. Examples are colour conversion filters, for converting a particular colour film for a particular light source (e.g. for using daylight balanced colour film in tungsten lighting), ultraviolet absorbing filters, and neutral **density** filters for absorbing light evenly from all parts of the visible spectrum in order to reduce exposure times.

Filters

There are two basic types of filters found in image processing programs such as **Adobe Photoshop**. Enhancement (corrective) filters include sharpening, and noise reduction, whilst creative (destructive) filters include a large range of distortion and 'artistic' effects. Filters are used extensively in scientific imaging for isolating detail from complex images, for example.

The mathematics of image processing is highly complex, but in simple terms, a filter is a mathematical weighting which can be applied to the whole image or selected part of an image. The formula can exaggerate the differences between adjoining pixels, re-map those pixels, or assign them different values. The filters are made up of '**kernels**' or blocks of pixels, usually 3×3, 5×5 or 7×7. The '**convolution** mask' contains coefficient or multiplication factors which are applied to the values of the pixels within the kernel and then summed to calculate each new pixel value.

For example, a 3×3 kernel consists of nine pixels, eight pixels surrounding the central one being processed. The central pixel has a value of 100, and its all eight neighbours have a value of 60. The sum total of the neighbouring pixels is therefore 480, which added to the 100 of the central pixel gives a total value of 580 for the whole kernel. This is divided by 9, giving a resulting value of 64. The central pixel is given this value, which is less than the original, making it therefore darker (or lighter if the image processing program used, e.g. Scion Image, has a **Look-Up Table** where white is given the lowest value).

The filter described above will be applied to all the pixels within the image (or selected area of the image) and has the effect of 'smoothing' (blurring or softening) the image, and is known as a 'low pass' filter. This type of image filtering is known as spatial filtering which affects the rapidity of change of grey levels (or colour) over a certain spatial distance. Low pass filters accentuate low frequency details leaving high frequency details attenuated or reduced, as a result.

Processing time will obviously depend on the size of the image and power of the computer. Applying such a kernel to a 640×480 greyscale image means that the process has to be applied $640 \times 480 = 307\ 200$ times. As each pixel will require nine multiplications and nine additions, this means that the whole image will require nearly three million calculations!

It is possible to construct your own filters in programs such as Photoshop in the 'Custom' filter menu (filter > other > custom). Experiment by typing in various figures into the grid.

An example of a simple sharpening filter is:

−1	−1	−1
−1	9	−1
−1	−1	−1

Examples of filters to trace edges:
Horizontal edges:

1	1	1
0	0	0
−1	−1	−1

Vertical edges:

−1	0	1
−1	0	1
−1	0	1

Programs such as Photoshop have **filter browsers** or previewing the effects of many (though not all) of the filters, and have facilities for combining two or more filters together.

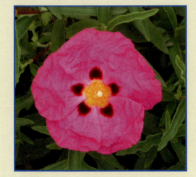

Original image.

Filter preview box: notice the combination of four filters used in the bottom right corner. Each one can be switched on or off like a layer or discarded.

A few examples of filters from Adobe Photoshop: extrude, find edges, selective blur, mezzotint, twirl, coloured pencil.

Custom filter box in Photoshop enabling users to create and preview their own filters.

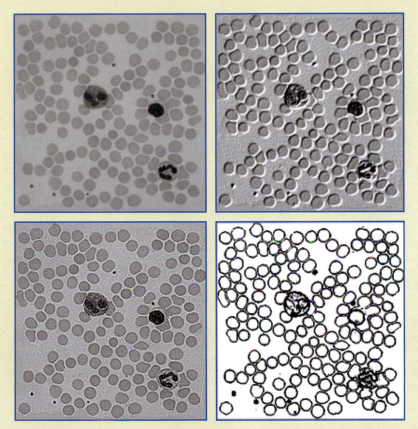

Use of filters in Scion Image to enhance a photomicrograph of blood cells for analysis: original image, shadow, sharpen, trace edges.

Filter Browser

The facility within image processing programs such as **Photoshop** and PaintShop™ Pro® to preview the effect of one or a combination of **filters** on an image.

Filter Browser: The facility in **Photoshop** and other programs to preview the effect of a filter or combination of filters on an image before applying them.

Filter gallery

See **Filter Browser**

FireWire (IEEE 1394)

A high speed data communications system linking computers and peripheral devices such as **digital** still and video cameras. It can transmit data at speeds up to 400 MBps. It was originally introduced in Apple computers but is now available for PCs as well. Sometimes known as **iLink**.

Firmware

Software that is stored permanently in **ROM** (Read Only Memory) so that it cannot be altered.

FITS (Functional Interpolating Transformation System)

The technology used by the largely redundant program **Live Picture**® for providing resolution independent images.

Flare

Unwanted, non-image forming light scattered within an imaging system causing loss of contrast, or showing up as bright streaks across the image.

Flash memory

A type of 'non-volatile' memory, in that any data in memory is saved, even when power is switched off. It is used in memory card systems such as **CompactFlash**®.

FlashPath

An adaptor for Smart Media™ **memory cards** enabling them to be read in a 3.5 in. **floppy disc** drive.

FlashPix

An image **file format** developed by Kodak, **Live Picture**®, Microsoft® and Hewlett Packard®. It is a multi-resolution image file format in which the image is stored as a series of independent arrays, each representing the image at a different spatial resolution. For example, if the original image is 1280 × 960 pixels, then the format would have versions measuring 640 × 480, 320 × 240, 160 × 120, 80 × 60 and 40 × 30.

This allows the image to be displayed on different **output** devices at different resolutions with minimal resizing of the image. Each version is divided into tiles of 64 pixels square. As the operator zooms in and out of the image, the **software** selects the appropriate resolution for the screen display. Any changes made to the image are recorded in a script, which is an integral part of the file. Any information here can be applied to any of the resolutions of image.

A FlashPix file generally requires 33% more disc space than a **TIFF** file (uncompressed) because of the extra resolutions contained within it. However, it requires about 20% less **RAM** for viewing than a comparable TIFF file and takes less time to modify it and store the revision.

Flatbed scanner

A **scanner** for both reflective and transparency materials. The original to be scanned is placed on a glass platen. With reflective materials, light from a fluorescent or halogen light source is directed onto the surface and reflected from it onto a **linear array CCD**, the width of the scanner unit. This unit is mounted on a moving element which transports the light and recorder in small steps between each scan. The scanner light reflects off the original as the light moves across it and the recorder detects variations in light reflected from the grey tones or colours in the original. With transparent materials, light from a light box built into the lid is directed through the transparency onto the CCD. The resolution of typical flatbed scanners ranges from 100 to 600 dpi, which may be **interpolated** to give higher resolutions. They generally have a smaller **dynamic range** than **film scanners**, up to around 3.4.

Flicker

The perception of a rapid variation in brightness when viewing a light or series of intermittent images that alternate with darkness. Persistence of vision prevents the effects of flicker with moving images when seen at specific rates. With **PAL** television, working at 50 Hz – the screen is 'redrawn' 50 times per second. However, with interlacing, only half of the image is redrawn at each pass, so that there is an effective framing rate of 25 **frames** per second. Computer **monitors** work at figures between 50 and 80 Hz, and are generally non-interlaced, so that the screen is redrawn at a rate of between 50 and 80 frames per second – i.e. each pixel is scanned at this rate. If the rates were too low, a flicker effect would result, which as users generally sit quite close to computer monitors would become very uncomfortable to look at after a time. The image on a computer monitor is therefore much more stable than a domestic television. Generally, a scan rate of 70 Hz and over should give a flicker free display. Some flickering

may become apparent if the brightness level is high, or occasionally may result from a strobing effect if fluorescent lighting is present. *See* **Vertical scan rate**

Flip

To laterally reverse an image from left to right or top to bottom.

Floating selection

When a selection is pasted into an image, it is known as a floating selection until it is de-selected or converted into a **layer**.

Floppy disc (or 'Diskette')

The name given to a 3.5 in. disc used for storing relatively small amounts of computer data. There are two capacities available, double **density** (storing approximately 700 KB) and high density (storing approximately 1.4 MB).

Floptical

The name often given to a 3.5 in. magneto-optical disc.

FM (frequency modulated screening)

See **Stochastic screening**

Focal length

The distance from the lens (strictly, the 'rear nodal point' of the lens) to the point of focus on the image plane when the lens is focussed on infinity. The rays of light entering the lens are thus parallel.

The 'standard' lens for any given format is derived from the length of the diagonal of that format, e.g.

24 × 36 mm = approximately 50 mm

6 x 6 cm = 75 mm

Many **CCD** sensors placed into conventional film cameras are smaller than the film they replace. The dimensions of the 6.3 **megapixel** chip used in the Nikon D100® **digital camera**, for example, are 23.7

× 15.6 mm. This means that the 'equivalent standard' focal length for this chip is approximately 30 mm. There is, therefore, an approximate 1.5 times magnifying effect with this particular camera – a 300 mm lens becomes effectively 450 mm.

23.7 mm

15.6 mm

24 mm

36 mm

Focoltone®

A colour matching system similar to **Pantone**® but less common.

Format

1. The process of preparing a disc for storing information. The process creates a 'map' which allows the data to be stored, catalogued and retrieved in an orderly manner. The disc is divided into sectors (segments) and tracks (concentric circles), the number of which determines the amount of data which can be stored. Generally, discs are formatted for a particular computer **platform** – **Macintosh** or **PC**, for example.

On the Macintosh platform, the process is known as '**initializing**'
2. The way in which a file is stored.
 see **File format**
3. The name given to a particular size, or ratio of film or television, e.g. 35 mm, widescreen.

FPO (for position only)

A low resolution version of an image used to indicate its placement within a document.
See **APR**

FPU (floating-point coprocessor)

See **Coprocessors**

Fractal

A complex mathematical principle, whereby a geometric shape has the property that each small portion of it can be viewed as a reduced scale replica of the whole. Fractal mathematics is being used increasingly in image **compression** routines. See **FIF**

FIF (fractal image format)

A **file format** for images which uses the principles of **fractal** mathematics for **compressing** the data. Relatively large savings can be made in the file size with very little loss of quality. The format is currently uncommon but may become increasingly important for storing large single images or for video sequences.

Frame

1. Video data is transmitted as two interlaced **fields** which make up one frame. In a 50 Hz system, one complete frame is transmitted every 1/25th second.
2. To compose an image in a viewfinder.

Frame grabber

Hardware that converts the **analogue** signal from an imaging device usually a video camera or video tape into a **digital** signal.

Full frame transfer

In this system, the full frame **CCD** sensor is exposed with a conventional shutter, eliminating the problem of **shutter lag**. Generally the pixels have a much larger active area than the interline transfer system, and have a greater **dynamic range**, lower **noise** and sensitivity.

FTP (file transfer protocol)

The method by which **software** can be downloaded from a remote computer.

Many computer companies maintain a free-access ftp site – anonymous ftp for software upgrades.

Gg

Gamma

In photographic sensitometry, gamma refers to the slope of the straight line portion of the characteristic **curve** of an emulsion. In **digital** imaging, it is a measure of the midtone image contrast, the relationship between input data from an electronic image and **output** data telling the **monitor** how to display an image. *See* **Linear gamma**

Gamut

The range of colours (or tones) which can be displayed or printed by a particular imaging system. Many programs and **colour management systems** have 'out of gamut' warnings indicating that colours displayed on a **monitor** are not reproducible by the printing system in use.

Gamut compression

The conversion from one **colour space** into another, where the starting colour space has a larger **colour gamut** than the resulting colour space. For example, the gamut of photographic film

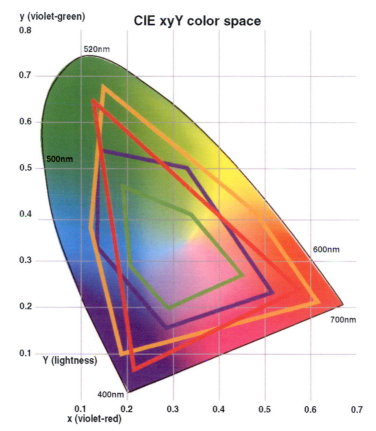

Gamut: CIE colour space model showing the gamut of various media. Orange: typical photographic film (transparency film). Red: typical computer monitor. Blue: typical quality printed material. Green: typical newsprint material.

is compressed for representation in the smaller **CMYK gamut** used for four-colour process printing.

Gamut mapping

The process of aligning the **colour space** of one device with another, achieved with algorithms or **Look-Up Tables**.

Gateway

A computer system located between and connected to networks using different **protocols**. It facilitates the exchange of information between networks.

Gaussian

A mathematical description of a certain type of **noise** or **blur**.

Gaussian blur

A **filter** in image processing programs which blends a specified number of pixels at a time, following the bell-shaped Gaussian distribution **curve**.

GCR (grey component replacement)

The practice of using black ink in place of a combination of cyan, magenta and yellow when printing images.

Generation

Successive copies of data are known as generations. With **analogue** systems, there is often some loss of data between one generation and the next, but with **digital** systems, there is no loss of data between generations.

Gicleé

Derived from the French 'to squirt', this term is usually reserved for fine art, limited edition inkjet prints on high grade archival quality paper.

GIF (Graphics Interchange Format)

An image **file format** developed in 1987 by CompuServe® for compressing 8 bit images with the aim of transmitting them via **modems**. It defines a **protocol** for the on-line transmission and interchange of **raster graphic** data. GIF uses **LZW compression** but is limited to 256 colours. It is independent of the **platform** used either in the creation of the file or the display.

GIF 87A

The original **GIF** format.

GIF 89A

The 89A version of **GIF** allows image transparency when used in **Web** pages on the **Internet**. It also allows progressive rendering of an image, whereby a low resolution of an image appears first, followed by increasingly higher resolution until the final version appears. The format also allows the user to store a sequence of still images which can be cycled to produce an animation effect – **Animated GIF**.

Gopher

A utility which enables users to search for, view and retrieve information from servers on the **Internet**.

Gradation

A gradual change of tone or colour.

Gradient tool

A facility within programs such as **Adobe Photoshop**® for producing graduated tones.

Grain

The individual silver particles which make up an image on a film emulsion. Silver grains are a mixture of shapes and sizes, and are a major factor

in determining resolution, overall image quality and 'look' of an image. **Digital** images do not have grain, so they lack the grainy characteristic of film. 'Grain' **filters** can be found in most image processing programs to put the effect back into images if appropriate.

Grey

A tone without any predominant colour. An equal mixture of red, green and blue light.

Grey balance

The balance between Cyan, Magenta, Yellow and Black printing inks, or Red, Green and Blue sensors to achieve a neutral grey without a dominant colour **cast**.

Grey card

A card with a matt surface printed to a neutral grey, and reflecting 18% of the amount of light falling upon it. It is used for assessing exposure and colour balance of images. The reverse side reflects 90% white and can be used for white balancing **digital cameras**.

See **Densitometer**

Grey ramp

A **curve** that defines the use of black ink in colour separations.

Grey scale

Strictly, a grey scale is a scale of neutral grey tones, from black to white, with an infinite range of greys in between. A grey scale 'step wedge' is a specific number of grey tones between black and white.

Greyscale mode

Displaying an image in 8 bit mode: i.e. black, white and 254 shades of grey.

GUI (graphical user interface)

A computer interface such as the **Macintosh**® or Microsoft **Windows**® **operating systems**, which use graphical **icons** to represent computer functions.

Guide number

The scale used to assess the power of a flash gun to determine the correct aperture. The correct aperture (f. no) is derived from:

f. no = GN/distance (metres)

e.g., f. no = GN 45/5 m = f/9

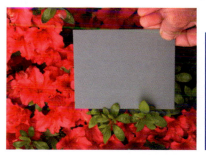

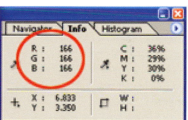

Grey card: A grey card being used to help achieve the correct colour in an image. The Info box in **Photoshop** shows equal density readings for the red, green and blue values producing a neutral grey.

Hh

Halftone

The process of printing continuous tone photographic images by simulating the continuous tone with a series of dots of varying sizes.

Magnified view of halftoned image showing structure of the halftone dot image. (original photograph courtesy Kodak/Bob Clemens.)

Halftone screen

A sheet of glass or film ruled with opaque lines, which when printed in contact with an original image produces a dot pattern, enabling continuous tone images to be printed with just black ink or four inks.

Halftoning factor

See '**Q factor**'

Halo

A pale line around object edges often caused by excessive **unsharp masking (USM)**.

Handles

The small rectangles which appear at the corners and edges of an object when it is **selected**. The handles can be dragged to change the size or shape of the object.

Hand scanner

An inexpensive reflection **scanner** based on a **linear array CCD**. The **scanning** action is carried out by moving the scan head manually over the print surface. An uneven rate of scan can lead to uneven image **density**. They generally have low resolution, and are not used for serious imaging.

Hard copy

A print or transparency.

Hard disc

The term used either for an internal or external rigid disc used for storing computer data. Many different capacities are available, and include several types which are encased in plastic and can be removed from the drive mechanism (e.g. Zip™ disc).

Hard proof

A guide print as to how an image will finally appear in a publication, e.g. **Cromalin**™.

Hardware

The physical components of a computer system – the **CPU**, **monitor**, keyboard, etc.

HDTV (high definition television)

High resolution television system containing about twice the number of scan lines (1000 or more) of present **NTSC**, **SECAM** and **PAL** standards.

Hertz (Hz)

A unit of frequency, equal to one cycle per second (cps). One kilohertz (KHz) equals 1000 cps, one megahertz (MHz) equals 1 million cps.

Hexachrome

A relatively new printing process based on **stochastic screening**, and using six printing inks – **CMYK** plus orange and green. It is capable of reproducing more colours on the printed page than traditional four colour printing.

hi-fi printing

A relatively new printing process based on **stochastic screening**, and using seven printing inks – **CMYK**, plus red, blue and green. It is capable of reproducing more colours on the printed page than traditional four colour printing.

High end

A term generally used for any part of the imaging chain (**scanner**, camera, computer, **output** device)

utilizing very high resolution files, usually for large posters and high quality magazine reproduction.

See **Low end**

High key

An image composed primarily of light tones.

Highlight

The brightest part of an image that is not a specular highlight.

High pass filter

A **filter** which sharpens an image by accentuating high spatial frequency detail and removing low frequency data.

High Sierra standard

A standard for defining the way data is arranged in the tracks and sectors of **CD ROM**s. It was adopted by the International Standards Organisation as **ISO 9660**.

Histograms

Image histograms (or 'Levels' in image processing programs such as **Adobe Photoshop**®) are graphical representations of the tones contained within an image, showing the relative number of pixels at different brightness levels within the image. They can show if an image is under or overexposed, high or low contrast, and whether detail has been clipped in shadows or highlights. Many **digital cameras** nowadays have the option of displaying the histogram alongside the image on

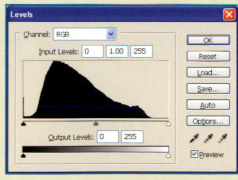

The Scottish river scene has a good range of tones shown by the histogram.

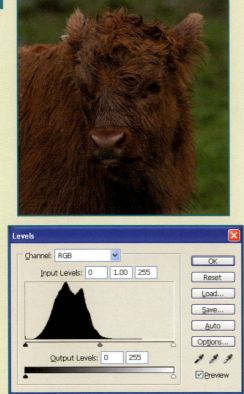

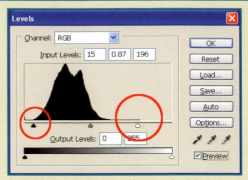

Autolevels: Note the 'auto levels' button in the dialog box. This automatically maps the darkest part of the image to black, and the lightest part of the image to white. It can cause colour shifts, and is best avoided for most work.

The image of the calf is low contrast, and the pixels are concentrated towards the middle of the tonal scale.

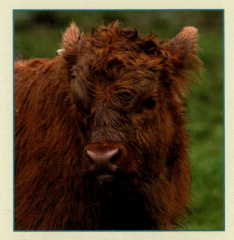

It is possible to improve this by moving the shadow and highlight sliders to the points at which the graph starts. This maps the darkest grey pixels to black, and the lightest grey pixel to white, improving the tonal range.

the preview screen, so that it is possible to tell, at the time of shooting, if the image has been exposed correctly or not.

The histogram of the river scene shows the tones within the image against the grey scale at the bottom of the dialog box, with a possible range of 256 tones from black (0) to white (255). There is a good range of tones, though there is a lack of pixels at the white end of the scale.

In the image of the calf: the tones are distributed in the centre of the grey scale, with no black or white tones. This explains the rather flat appearance of the image taken in dull, overcast light.

The levels box can be used to re-distribute the pixels so that the very darkest point is given a value

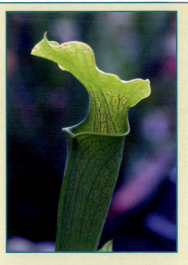

Thresholding: A useful feature found in programs such as Photoshop is the 'threshold mode' showing you the brightest and darkest parts of the image, allowing you to set very precisely the threshold point at which the tones appear. Make sure the preview box is checked, then hold down the alt key whilst clicking on the highlight or shadow slider. With the highlight slider the screen goes black, and the brightest highlights start to appear. With the shadow slider, the screen goes white, and the darkest tones start to appear. For most images, the correct settings will be the point at which tones start to appear at each end of the histogram. Remember though that not every image will have a black and a white tone.

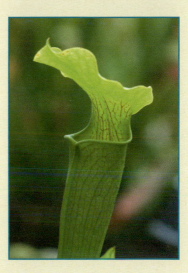

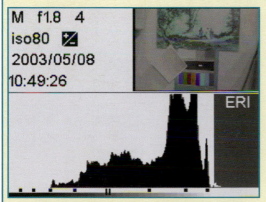

The **LCD** display on the rear of a typical digital camera, showing the image, exposure and date information and image histogram.

of 0, and the lightest area, a value of 255. The central slider is used to lighten or darken the whole image within the two range set by the highlight and shadows.

Histogram sliding

The addition of a constant brightness value to every pixel in an image. The effect is to 'slide' the **histogram** to the left or right.

Histogram stretching

Multiplying every pixel in an image by a constant value. The effect is to stretch or shrink the **histogram**.

History

The facility within **Photoshop** and other image processing programs for recording the various operations that have been applied to an image. It can often be saved as a log, which could provide an 'audit trail' for legal purposes.

HMI (hydrargyrum medium arc iodide)

A special type of metal vapour light source which is continuous and **flicker** free, and is recommended for certain **scanning** types of **digital camera**. It has a **colour temperature** of approximately 5600 K, similar to daylight.

Home page

The opening introductory screen of a **Website**. The home page may contain an index of other pages or links to other areas of the site.

Hot mirror filter

An optical filter which reflects **infrared** radiation and transmits visible light. It is recommended for use with some **digital cameras** to improve colour rendition.

HSB colour model (hue, saturation and brightness)*

Saturation is the strength or purity of the colour. It represents the amount of grey in proportion to

The location of the peak of the curve relative to **wavelength** determines **hue.**

The **shape** of the curve determines **saturation.**

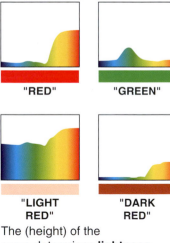

The (height) of the curve determines **lightness.**

Indistinct shape and no predominant colour gives low saturation.

hue, and can be expressed as a percentage: 0% (grey) to 100% (fully saturated). Fully saturated colours are shown around the perimeter of a wheel. The centre of the wheel represents lowest saturation. Brightness is the lightness or darkness of a colour. Zero brightness equals black. Full brightness combined with full saturation results in the most vivid version of a colour.

HSL colour model (hue, saturation and luminosity)

Similar to the **HSB colour model**. Zero luminosity equals black, but full luminosity equals white. Thus, vivid versions of colour require medium luminosity. This mode is no longer included within **Adobe Photoshop**®.

HSV (hue, saturation and value)

Same as **HSL**

HTML (hypertext mark up language)

This is the computer language used by the **World Wide Web** for constructing pages with information. This data which can be text, images, etc., can be 'linked' to other pages. Many **software** packages such as Microsoft Word® have HTML editing facilities.

HTTP (hypertext transfer protocol)

The search and retrieve **protocol** used for transferring **hypertext** files across the **Internet**.

Hue

The wavelength of light reflected from or transmitted through an object. It is identified by a name, e.g. red, green, or yellow.

Huffman encoding

A type of **Run Length Encoding (RLE)** used in **data compression**.

Hybrid imaging

Any imaging system using a combination of silver based and **digital** technologies. Examples are the **APS**, and **PhotoCD**, where silver based film is scanned onto **CD ROM**.

Hypermedia

Information in electronic form which links to other media.

Hypertext

Text that contains a link to another piece of text or information. Hypertext words are usually in a different colour in documents.

Ii

IBM® (International Business Machines)

At one time the world's largest manufacturer of personal computers.

IBM compatible personal computer

Any personal computer capable of running **MS-DOS®** or **Windows®** applications.

IC (integrated circuit)

A semiconductor circuit that has more than one transistor and other electronic components, and can perform at least one electronic circuit function.

ICC profile

A standardized set of figures used to characterize the colour and other attributes of a **scanner**, **monitor** or printer, produced to **ICC** specification. Within colour management, device **profiles** are used to control the colour workflow between original, screen image and final **output**.

ICC (International Colour Consortium)

A group of eight industry vendors (including Adobe®, Microsoft®, Apple®, and Gretag Macbeth®), established in 1993, for the purpose of creating, promoting and encouraging the standardization and evolution of an open, vendor-neutral **colour management system**.

ICE® (Image Correction and Enhancement)

Proprietary **software** used by many **scanner** manufacturers for removing scratches, dust or fingerprints from images at the time of **scanning**. This is accomplished by obtaining information about the nature and location of surface and near-surface defects as an image is scanned. During the scanning process, red, green and blue image information is gathered utilizing **RGB** channels. **Digital** ICE scanning uses a fourth channel, referred to as the defect or 'D' channel, to collect the 'defect information'. Once this has been recorded in the D channel, complex algorithms are used to erase the defects without degrading the image.

ICM (Microsoft Image Colour Management)

Facility within the Windows **operating system** for consistent colour management across input and **output** devices.

Icon

A symbol on a computer screen representing an operation or group of operations.

IEEE (Institute of Electrical and Electronics Engineers)

The IEEE is best known for developing standards for the computer and electronics industry. In particular, **FireWire®**, **IEEE 1394**, and the 802 standards for **WiFi** local area networks are widely followed.

IFF (interchange file format)

A native image **file format** used by Amiga computers.

IIQ RAW (intelligent image quality RAW)

The name given to the **RAW** image **file format** from cameras manufactured by Phase One®. It incorporates **lossless compression** to reduce the size of the files.

iLink®

Alternative name for **Firewire**.

Image analysis

A set of **tools** to enable measurements and other data to be taken from images. The analysis may be of morphology (size or shape), intensity, **density**, texture or reflectance of the subject matter. Image analysis **software** can also be used to make information within images easier to see.

Image analysis: A screen shot of Scion Image, an image analysis software, showing a density trace across the image. Other features include the ability to count particles and measure their length, perimeter and area.

Image averaging

A technique for reducing the effects of random **noise**, where two or more **frames** are taken of the same scene and the results are averaged. It is only appropriate with static subjects.

Image Pac™

The Kodak **PhotoCD** system of storing image data that contains all resolutions from **64 Base** to **Base/16** (Pro-PhotoCD). Image Pacs on Master PhotoCDs will only contain 16 Base–Base/16.

Image processing

Techniques that manipulate the **pixel** values of an image for some particular purpose, e.g., correct brightness or contrast, change the size (scaling) or shape of images, enhance detail or enable scientific analysis of image data.

Image rendition

The mapping of image data representing the original scene to the image data representing the **output** elements.

Image resolution

Digital images from **digital cameras** or **scanners** are composed of a square or rectangular grid of pixels. The resolution of digital images is quoted in the number of pixels per (linear) inch, or the total number of pixels in an image – usually millions of pixels (**megapixels**).

Note: *The resolution of **image scanners** is, confusingly, often quoted in dots per inch, dpi (or samples per inch, spi, in the case of older models).*

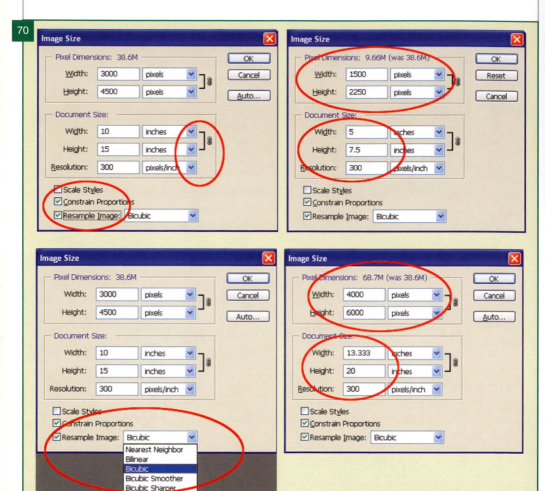

In the example shown (Figure Image size 1), the image from a 14 megapixel digital **SLR** camera consists of 3000 × 4500 pixels, giving a file size of 38.6 MB. It would print at a size of 15 × 12 in. if printed at a resolution of 300 pixels per inch. Note that in this case the resolution, width and height are linked with a chain. Changing one of these figures, from 15 to 20 in. height, for example, will alter the other two figures, whilst retaining the same number of pixels (Figure Image size 2).

It is also possible to change the number of pixels in the image through the process of **interpolation** (or **resampling**). If the 'resample image' box is checked (Figure Image size 3), note that the resolution, width and height figures are no longer joined with a chain. You can now alter the figures to the required amount, and the software will either add (interpolate) extra pixels, or discard those not required.

For example: if an image needs to be interpolated from 400 to 800 ppi, or 6 × 6 to 12 × 12 cm, there are three main methods (Figure Image size 4) (algorithms) found in

71

software such as **Photoshop**. The mathematics is complex, but simply they are:

1. an algorithm that copies every pixel and makes it the next one. This is known as '**nearest neighbour**' interpolation, and is the quickest, but gives the lowest quality
2. an algorithm that takes the average of adjacent pixels to produce the intermediate pixel, usually known as '**bilinear**' interpolation
3. an algorithm that produces a new pixel based on the average of pixels surrounding it. This is known as '**bicubic**' interpolation, of which there are three variants in Photoshop CS.

These settings relate to the different mathematical methods used in the interpolation process, of which bicubic gives the best result. Use bicubic 'smoother' for increasing resolution, bicubic 'sharper' when reducing resolution.

Interpolation affects the overall file size of the image. For example, halving the required print size to 5×7.5 in. reduces the file size from 38.6 to 9.66 MB (one quarter of the original) (Figure Image size 5).

Similarly, increasing the required print size to 20×13.3 in. increases the file size to 68.7 MB (Figure Image size 6).

Imagesetter

A high resolution device producing **output** onto film or photographic paper usually at resolutions greater than 1000 dpi. Usually a **PostScript** device.

Image sensors

There are a number of sensors available for **digital cameras**, the two commonest being CCD and CMOS. Each type has several variants. Basically, an image sensor contains a grid of minute light sensitive pixels (photosites) which act like a photo-generative light meter, measuring the amount of light falling upon them, and generating an electrical current in proportion to its intensity. This **analogue** current needs to be **digitized** in order for it to be readable by a computer.

CCD (charge coupled device)

A solid state image pick-up device composed of a rectangular matrix (**area array**) or single row (**linear array**) of light sensitive **picture elements** (pixels or photosites). Their operation is highly complex and only a brief explanation can be given here.

Light falling on to the elements produces an electrical charge in proportion to the amount of light received. This voltage is in **analogue** form and must be converted to digital by means of an **ADC** before it can be **output** to the computer.

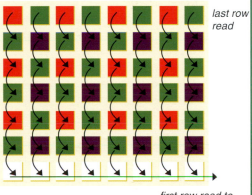

last row read

first row read to output amplifier

Basic operation of CCD: The charges from the individual photosites are read out one line at a time. The first row is read to a register, then to an amplifier before being converted into a digital signal. The charge is deleted and the next row is read. The last charge on each row is coupled with the first one on the next row.

The individual photosites are arranged in rows, and the charge generated at each one is read out a

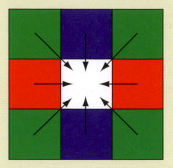

Color creation: The final colour of each pixel is determined from a balance of itself and the colour of the pixels surrounding it.

line at a time. The first row is read to a register, then to an amplifier, and finally converted into digital data. The charge is deleted, and the next row read. The last charge on each row is 'coupled' to the first one on the next row. A useful analogy is a stadium full of people each of whom has a piece of paper containing a number. Assuming the seats to be on a conveyor belt, all the seats in a row are moved one step nearer the aisle at a time. The stadium is emptied one row after another, starting at the top. As each person reaches the aisle, they hand their numbered paper to an official.

There are two basic types of CCD – **Full Frame** and **Interline**.

Full Frame sensors are usually found in Digital **SLR**s and backs which attach to medium and large format cameras. They are exposed using a conventional shutter, and do not suffer from shutter lag. The percentage area of the individual pixel on a CCD or CMOS sensor that is active in light gathering is known as the fill factor. Typically, full frame CCDs have a fill factor of 90%, making them highly efficient.

Interline sensors are found in compact types of digital camera, and were originally designed for capturing video sequences. The sensor does not strictly require a shutter. Light falling on the photosite forms a charge. The charge on a

complete row is moved across the surface of the sensor. The sites and the adjacent vertical readouts act as a full frame shift unit. The vertical readout is masked, effectively putting a roof over it, protecting the charge from the effect of any light forming on the surface of the sensor. In this way, an image can be read from the sensor whilst another is being formed at the photosite. This ability to operate without the need for a shutter allows the production of a stream of images. It is possible to view the subject on the LCD screen on the rear of the camera as a live video signal. The fill factor is much lower than a full frame CCD – typically just 30% of the sensor area. This is often compensated for in the sensor manufacture where a micro lens is formed over each pixel, increasing light gathering power. This can lead to unwanted optical effects, particularly with wide angle lenses.

CMOS sensors

CMOS sensors are becoming increasingly common in digital cameras. They tend to be cheaper to manufacture. Each pixel contains both photodiode and transistor to select, amplify, digitize and transfer the charge. This means that image processing can take place during capture rather than at a later point.

Super CCD

The Super CCD, developed by Fuji® uses octagonal rather than square pixels, enabling a greater surface area per pixel. The latest generation, the Super CCD SR and HR incorporate both large, high-sensitivity S-pixels and smaller R-pixels for greater **dynamic range**.

Foveon® sensor

In 2002, Foveon® produced the X3 sensor, differing from a conventional CCD in that it has three layers of pixels, each sensitive to either red, green or blue (similar to film which has three layers of chemical emulsion). The layers are embedded in silicon to take advantage of the fact that red, green and blue light penetrate silicon to different depths.

Diagram of Fuji® Super CCD sensor with octagonal shaped pixel and smaller pixel for highlight recording.

Colour capture

Essentially, image sensors are monochrome devices, measuring the amount of light falling upon the individual sensors. Various systems have been used over the years:

1. The image is exposed three times, successively through red, green and blue filters, with the full colour image being re-constructed in the computer.
2. The image is recorded onto three separate CCD sensors, the light passing through the lens being split into its component red, green and blue values by a beam splitter.

These systems are now largely redundant, having been replaced by a colour filter array, where each individual picture element is coated with a transparent filter, in a particular pattern. Various patterns exist, but the general rule is to divide the sensor into clusters of four sensor sites, one red, one blue and two green. The extra green is to bring the sensitivity of the CCD into line as far as possible with the human visual system, which is most sensitive to green light. This is known as a '**Bayer array**'.

(A variant to this system has been used by Kodak® for some of its professional cameras, using cyan, magenta and yellow filters rather than red, green and blue. As these complementary colours transmit twice as much light as the primary colours, so the sensor is effectively twice as sensitive.)

Resolution

The resolution of imaging sensors is usually quoted either in the vertical and horizontal number of pixels, or the total number of pixels in the sensor:

For example, 4500×3000 pixels = 13.5 million (mega) pixels.

Sensitivity

Sensors are given an effective ISO rating. This can be increased by amplifying the signal. Many modern digital cameras have effective ISO ratings of 100 ISO, which can be increased to 200, 400, 800 and 1600 ISO. Increasing the ISO speed may cause an increase in '**noise**'.

Many CCD and CMOS sensors are inherently sensitive to both ultraviolet and **infrared** radiation. Most, at the time of manufacture, have an ultraviolet absorbing filter cemented over the surface of the CCD to minimize the amount of ultraviolet recorded, though for scientific uses, sensors can be manufactured without this filter. Similarly, many cameras are supplied with infrared absorbing filters, to cut down the infrared in the light source, and achieve a neutral colour balance. Many digital cameras can be used for recording infrared with the appropriate filter.

Sensor size and focal length

The size of the CCD may be smaller than the film which it is replacing. This will affect the effective focal length or field of view of the lens being used.

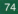

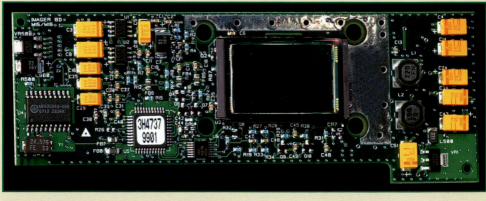

Comparison between 'mosaic' capture with CCD, and Foveon® multi-layered sensor:

Mosaic capture

1. Bayer pattern on conventional CCD sensor, with one red, one blue and two green filtered pixels.

2. Each pixel is sensitive to just red, green or blue.

3. Only a quarter of the pixels capture red and blue, and half capture green light.

Foveon® multi-layered sensor

1. This particular sensor has three separate layers of pixels embedded in silicon.

2. Because silicon absorbs different wavelengths of light at different depths, each layer captures a different colour.

3. Red, green and blue light is captured at every pixel location.

CCD sensor and associated circuitry from digital camera.

For example, a 6 million pixel sensor measuring 23.7 × 15.6 mm will effectively multiply the focal length of the lens by approximately 1.5× in relation to 35 mm film. Thus a 300 mm lens becomes effectively 450 mm when used with this particular sensor.

Linear array CCDs are used in scanners, and in 'scan backs' which fit onto the back of medium and large format film cameras in place of the film holder. They scan the image projected by the lens during exposure. This can take several minutes, limiting the use of such devices to still life subjects lit with continuous light sources such as daylight or HMI lighting. They can achieve higher resolution than area arrays. The resolution can be altered by increasing or decreasing the scan rate.

Linear array CCDs may either be one row of elements, which, when recording colour, scans the image three times, once for the red, green and blue components of the image, or three parallel rows of sensors filtered for the colour. This is known as a **'trilinear array' CCD**. The resolution of a linear array is quoted as pixels per inch, or (confusingly) dots per inch. For example, if a linear CCD is 8.5 in. wide, and contains 5080 pixels, then the maximum scan resolution possible is 5080 divided by 8.5 = approximately 600 pixels (sometimes 'samples') per inch.

Images for websites

Photographers and image libraries now use the **Internet** extensively for displaying and marketing images. It is very important that they are sized and saved appropriately, so that they are not too

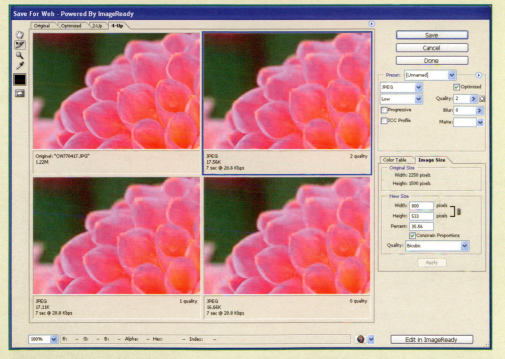

The 'save for web' setting in **Adobe Photoshop**. Various levels of JPEG compression are shown, enabling the user to preview the quality of the final image.

A simple web site created in Adobe Photoshop (File > automate > web photo gallery . . .). Each image on the left hand side can be clicked to bring up a larger version in the main area of the screen. Various templates are included, as well as options for changing background colours and the like.

large, taking too long to download, yet are of sufficient quality to show the image to its best effect.

The usual recommendation is to re-size images to a resolution of 72 ppi (the resolution of most computer monitors) and at the size the image will appear on screen, for example 800 pixels wide. Images should be saved as **JPEGs**, to ensure that they are small enough to enable fast downloading.

Most image processing programs such as **Photoshop** and PaintShop™ Pro® have a 'save for web' option, where the image can be previewed at various compression settings. The time taken to download can be seen.

Many of these programs can also automatically generate web pages for displaying images, with a variety of templates. In the example shown the 'automate > web photo gallery . . .' command was used in Photoshop CS. The appropriate folder was selected, and one of the template options chosen. Each of the images on the left hand side is a **thumbnail**, and when clicked on links to a high resolution version. Many more sophisticated web authoring programs are available, such as Adobe GoLive® and DreamWeaver®.

Image stabilization

Facilities built within both still camera lenses and video cameras for reducing the effects of camera shake.

IMG

A largely redundant **bitmapped** image format, used by programs running under the GEM® windowing environment.

Indexed colour

A single-channel image with 8 bits of colour information per pixel. The index is a **CLUT** containing up to 256 colours. This range of colours can be edited to include only those found within the image. **Digital** images in multimedia programs are often in indexed colour mode.

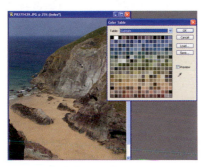

Indexed colour: The colour table for an image converted to indexed colour showing the 256 colours present.

Index print

A page of small, low resolution, numbered 'thumbnail' images used as a reference for the contents of a roll of film or **CD**, for example.

Info palette

A facility within **Photoshop** and other imaging programs for measuring the **density** and colour

value of **pixels**, and locating them within the **bitmap**.

Infrared

Electro-magnetic radiation with wavelengths from approximately 700 to 900 nm. Many **CCD** and **CMOS** sensors are inherently sensitive to infrared radiation, and many cameras can produce excellent infrared images when fitted with an infrared filter such as a Kodak Wratten 87A. Other models are fitted with infrared absorbing **filters** over the CCD to minimize its' effects.

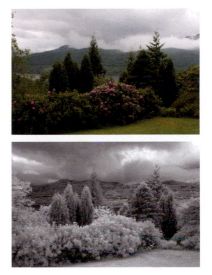

Infrared: A visible light image and an infrared version of it. Note the increased contrast in the sky. The image was shot on a Nikon 100® **DSLR** camera, with a Kodak Wratten 87A filter.

Initialize

The term used with **Macintosh**® computers for formatting **floppy discs**.

78 | Ink jet printer

This is one of the cheapest forms of computer printer, yet one capable of producing photographic quality prints. '**High end**' ink jet printers producing nearly photographic quality prints at large sizes are available. The system usually uses four colours: cyan, magenta, yellow and black ink, with some 'photo' models using extra light cyan and light magenta inks. (Some printers can be fitted with 'quad black' ink sets for producing monochrome prints, and limited **gamut** inks are available for producing controlled subtly toned prints.) The cartridges contain liquid ink which is forced into a tiny nozzle either by the application of heat or pressure. As the ink heats, it forms a tiny bubble at the end of the nozzle, hence the common name of '**bubble jet**' printers. Recent models use pigment rather than dye based inks, which are more resistant to fading.

All ink jet printers work best with dedicated, coated paper types, as the absorbency of the paper controls the brightness and definition of the image. It is possible to use good quality 'art' paper for exhibition purposes. Although the printing process is relatively slow, the technology has the advantage of working at any size and by a process of scaling up the transport mechanism and the size of the nozzles, printers can be made to **output** prints A0 size and larger. Another method of ink delivery is the **phase change ink jet**, generally employed in relatively expensive printers.

Ink jet printing

Ink jet printers are now one of the commonest ways of producing images from digital files, and superb quality can be obtained from them if both the image file and the printer are set up in the right way.

First of all, use the best quality ink and paper. Do not be tempted by cheap 'refill' inks, they are often not as good as the manufacturers' own ink, and may clog the nozzles in the print head. They will also have different colour characteristics, and therefore require a completely different profile to

Typical six colour photo quality ink jet printer.

Original image from a six megapixel camera, showing a print size of 12.5 × 8.3 in. if printed at 240 pixels per inch.

the one supplied with the printer. Several companies such as Lyson®, produce archival ink sets, and these will be supplied with their own **ICC profile**.

Similarly with paper, find a type (or types) that suit you and then stick with them, and learn their characteristics. When profiling a system, you will need a different profile for each ink and paper combination. The manufacture of ink jet paper is a

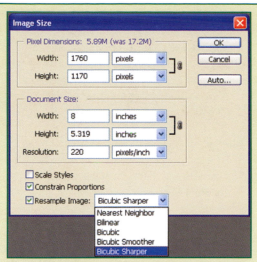

The image re-sampled to 8 × 5.3 in. and at a resolution of 220 pixels per inch using 'bicubic sharper' interpolation. Note change in pixel dimensions at the top of the screen, from 17.2 to 5.89 MB.

Printer dialog box showing media type, and printer resolution.

complex process, and papers will vary in their drying time, sharpness and density of the base white. The same image, printed on two different 'photo quality' papers, for example, may vary enormously.

A printer bought specifically for the high quality printing of digital images will usually have six inks: black, cyan, magenta and yellow, plus light cyan and light magenta, to provide a greater depth of colour.

Preparing the image

The resolution of a printer is quoted in dots per inch (dpi). Typical values are 720, 1440 and 2880. The resolution of the image is in pixels per inch (ppi). Due to the dithering process, i.e. the way that pixels are created by dots of ink, the resolution of the printer will usually be in the range 180–240 ppi. Test your own printer, but generally, excellent quality prints can be obtained by setting the image size to 220 ppi. (*See* **Image resolution** for more details on re-sizing images.)

Only after getting the image to the right size for printing should you apply the unsharp mask filter. Again, test various settings, with different types of image.

Setting up the printer

Once the image is ready to be printed, the printer now needs to be set up correctly. You will need to access the advanced controls of the printer. There are two main settings that need to be altered.

Firstly, the media type – this must be set for the paper you are using. This setting determines the amount of ink that is laid onto the paper (the 'gloss' setting will put less ink onto the paper than cheaper plain paper). It is very important to get this right. If you are using a paper that is not listed (e.g. canvas) than set the printer to 'photo quality glossy film'.

The other main setting is the 'print quality'. For high quality photographic printing, use the 1440 or 2880 setting (it is worth doing tests with these settings – you may not be able to see any difference between them).

Do not use the 'high speed' setting (unless you have a large number of prints to produce, or the 'smooth edge' feature which is designed for low resolution images.

Note: *These features refer to Epson® printers. Other manufacturers will have very similar settings.*

Tips

1. Turn off the screen saver when making large prints. If this 'kicks in' whilst the printer is operating, a line may appear on the print at the moment it starts to run.
2. Print all images in 'portrait' orientation. If you send a horizontal landscape format image to the printer, where the paper is fed vertically in portrait mode, then the printer has to rotate all the pixels by 90°. This will slow down the process.
3. To avoid wasting paper, make small test prints by re-sizing the image without re-sampling, e.g. make a 5 × 4 in. test print of an image that will be printed finally at 10 × 8 in. Make sure the resample box is not ticked. The resolution will increase to a high figure, but this will not affect the density and colour of the print. Re-set the size back to 10 × 8 in. once you have achieved the right colour and density.

Integration time

The exposure given to pixels on a **CCD**.

Intent

See **Rendering intent**

Interference filter

Also called **dichroic filters**, these filters look like mirrors. They transmit one colour, and reflect another, complementary colour. For example, one type may transmit green and reflect magenta light. They work not by absorbing unwanted wavelengths of light, but by interference effects within the multiple layers of the filter.

Interlacing

The television **scanning** system where the sets of lines in each pair of fields is displaced vertically so as to alternate with each other.

Interline CCD

The type of CCD used in many compact types of **digital cameras**. The sensor itself can act as a shutter, using **software** to start and stop the exposure process. It produces a live video signal, which can be viewed on the rear screen of the camera.

Internet

The worldwide network which links computer systems together, using the **TCP/IP protocols**. *See* **World Wide Web**

internet

The connection of two or more computer networks.

Interpolation

A method for increasing (or decreasing) the apparent resolution of an image, whereby the **software** mathematically averages adjacent **pixel** densities and places a pixel of that **density** between the two. There are various methods of interpolation including '**nearest neighbour**', '**bicubic**' and '**bilinear**'. Excessive interpolation may result in images with a blurred and unsharp appearance.

Intranet

A network of computers, usually within a single organization, and accessible only for permitted users.

I/O

The standard abbreviation for data input and **output**.

Ion® (Image Online Network)

The name of the first consumer still video camera system, manufactured by Canon® in 1989.

IP address

A unique numeric representation of the location of a computer within a network. It consists of four

sets of numbers separated by periods (sometimes called 'dotted quad'), e.g. 135.123.245.9.

IPE (Image Pac™ extension)

The **64 Base** component of the Pro-**PhotoCD** format is stored in a separate directory, known as the Image Pac extension on the disc, and accessed when required by specific acquisition **software**.

IPTC (International Press Telecommunications Council)

The organization responsible for setting standards for image transmission. In particular they define standards for transmitting text data such as captions, copyright notices, and keywords.

IrDA (Infrared Data Association)

The system for transferring images from **digital cameras** to computers using **infrared** signals.

ISO 9660

An international standard specifying the logical **file format** for files and directories on a **CD ROM**.
See **High Sierra**

ISDN (Integrated Services Digital Network)

A telecommunications standard allowing **digital** information of all types to be transmitted via telephone lines. It can provide speeds of up to 128000 bits per second.

Ishihara colour test

A set of standard charts which are used to diagnose colour blindness and other faults in human colour vision.

ISO rating

The rating applied to photographic emulsions to denote their speed or relative sensitivity to light. The sensors used in **digital cameras** have 'equivalent' ISO ratings, to enable comparison with

film, and can usually be varied, for example, from 100 to 1600 ISO.

ISP (Internet Service Provider)

A company which provides access to the **Internet**, usually for a fee, e.g. CompuServe®.

IT8

An industry standard colour reference chart used to calibrate **scanners** and printing devices.

IT8 target: An industry standard IT8 target used to help calibrate scanners and other devices. There are several different versions available.

IVUE file

The **file format** used by **Live Picture®** **software** to work with its **FITS** technology. Image editing actions are stored mathematically in a FITS file, while the original pixel data is saved in the IVUE format. A new **output** file is created from the original IVUE image based on the FITS file in a single, final RIP process that avoids cumulative processing error. The major advantage of the format is its ability to deal only with that portion of an image being edited, thereby greatly speeding screen display between edits. An IVUE file is generally approximately 25% larger than the original **TIFF** file.

IX 240

The technical name for the **APS** film format.

Jj

Jaggies
See **Aliasing**

Jaz® drive
A removable **hard disc** system using 3.5 in. discs of 1 GB capacity.

JFET LBCAST
See **LBCAST**

JFIF (JPEG file interchange format)
A **file format** which enables **JPEG** bitstreams to be exchanged between a wide variety of computer **platform**s and applications.

JPEG (Joint Photographic Experts Group)
A widely used **lossy compression** routine for the storage of still photographic images. Users can specify the amount of **compression** used, when saving the image. 'Progressive **JPEG**' allows successive rendering of the image, whereby a low resolution of an image appears first, followed by increasingly higher resolution until the final version appears. It is widely used when placing images in **Web** pages on the **Internet**.
 See **Data compression**

JPEG 2000
A new and relatively uncommon version of **JPEG**, which uses 'wavelet technology' to compress images without the loss of data.

Jukebox
A device for holding a large number of **PhotoCD**s, any of which can be readily accessed, thus forming the basis for an image library system.

Julia set
A type of **fractal**.

Kk

K

1. (Abbreviation Key) The process colour black used in four colour printing
2. The scale used when defining the resolution of **film recorders**
3. The annotation for **colour temperature** using the Kelvin scale, e.g. 5500 K.

Kernel

The group of pixels used in a **convolution** process.

Kerning

The process of adjusting the space between two adjoining characters to optimize their appearance, usually in a desktop published document.

KPT® (Kai's Power Tools)

A series of **plug-in filters** for **Adobe Photoshop®**. They include special effects **filters**, texture generators and **fractal** pattern generators.

LAN (local area network)

The linking together of computers and **peripheral** devices such as printers within a small geographic area such as a room or single building.

Land

The surface of the reflective layer of a **compact disc**.

Laptop

The term given to a small portable computer. Many now have the ability to run image processing programs, and are used extensively by photographers for downloading images from **digital cameras** and editing images 'in the field'.

Laser (light amplification by stimulated emission of radiation)

A light source emitting an intense beam of coherent, monochromatic light.

Laser disc

A 12 in. (30 cm) optical disc used for storing video images and sound data in an **analogue** format.

Laser printer

A printer containing a rotating metal drum, coated with a fine layer of photosensitive material. An electrostatic charge is applied to the whole drum. This charge on the drum can be removed by applying a light to its surface. The image to be printed is applied to the drum via a laser beam or row of LEDs (light emitting diodes). A negative image of the subject to be printed is projected onto the surface of the drum. The result of this is to 'undraw' the image on the drum as it rotates, a process similar to producing a statue by chipping away all pieces of stone until the statue is complete. The end result of the operation is to leave an '**image**' of the original as an electrostatic charge on the drum. The drum rotates past a toner dispenser containing ink. The ink used has an electrical charge and is attracted to the charged image on the drum. This can then be transferred onto paper by giving the paper the opposite electrical charge. The ink is then attracted from the drum onto the paper, the paper giving a black ink image on the paper. The light source scans across the surface of the drum forming the image by a series of overlapping individual dots. The minimum size of the dot is the width of the light beam as it is focussed on the drum. This means that all images are formed by multiples of a single dot. Note that the size of this dot does not change – larger dots can be formed by groups of overlapping dots. Colour laser printers use four drums, and store image colours in cyan, magenta, yellow and black elements.

Lasso

The lasso **tool** in image processing programs such as **Photoshop** allows the user to draw a freehand selection around parts of an image.

Layer

A feature of **Photoshop**, and other image processing programs, where the original image is known as the 'background'. Other images, or versions of the original image, can be overlaid on the top of the background image as 'layers'. Large numbers of layers can be stacked onto the background, and individual layers can be adjusted in terms of their **opacity** and the like, or moved in relation to the background.

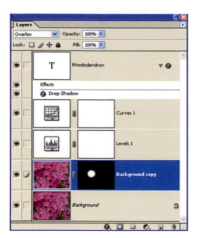

Layers: The layers dialog box in Photoshop, showing adjustment layers or levels and **curves**, a text layer with 'drop shadow' effect, and a **layer mask**.

Layer mask

A mask that can be applied to an image, or elements of an image within a particular **layer**. Various options such as **opacity** and softness (**feathering**) can be applied to the mask.

LBCAST (lateral buried charge accumulator and sensing transistor array)

The **imaging sensor** used in a range of professional Nikon® **digital cameras**, similar in structure to **CMOS** sensors, but with a faster read-out of data.

LCD (liquid crystal display)

A technology used particularly for screens on portable **laptop** computers, and small preview screens on **digital cameras**. A liquid crystal is a semi-liquid, gelatin-like crystal of organic molecules, which changes its chemical structure when it receives an electrical voltage. As its character changes, the light passing through it changes. The screen of an LCD **monitor** display is composed of thousands of tiny cells, each of which contains a liquid crystal. Each cell receives a signal which makes it transmit more or less light from a backlight behind the screen. Colour **filters** may be incorporated over the cells to produce colour images. There are two basic types: **Passive Matrix LCD** and **Active Matrix LCD**.

LCLV (liquid crystal light valve)

A technology for producing continuous tone colour prints and transparencies onto silver based photographic media. **Digital** data is written by a laser onto three LCLV cells, and then the image is projected by tungsten light onto photographic media and processed.

LCOS (liquid crystal on silicon)

See **Data projector**

Legacy file

A file generated in a previous edition of a piece of **software**.

Lens distortion

Linear distortion introduced by the optical construction of a compound lens, e.g. **pin cushion** and **barrel distortion**.

Levels

The term used in image processing programs such as **Photoshop** for the dialog box containing the image **histogram**, and controls over the input and **output** values of the image. Many **digital cameras** display the histogram for images on the rear LCD display screen.

Lightness

Tones in relation to a scale of greys. Whites are greys of high lightness and blacks are greys of low lightness. In prints, highlights are tones of high lightness and shadows tones of low lightness.

Limited gamut ink

Ink sets for **ink jet printers** allowing the user to produce monochrome prints with a precisely controlled hue.

Line art

The term given to diagrams consisting of black lines on a white background, or vice versa (i.e. **binary**).

Linear

Any system where **output** is directly proportional to input.

Linear array CCD

A single row of **picture elements** which is made to travel across an image projected by a lens (in a **digital camera**), or across a print or transparency, thus **scanning** it in order to convert **analogue** information into digital data. Resolution is quoted as number of pixels/elements per inch or centimetre. Tri-linear **CCD**s have three lines of picture elements each coated with a primary **filter** – red, green or blue.

See **CCD**

Linear gamma

A **gamma** value of 1.0. **Digital cameras**, shooting in **RAW** mode, capture images with a linear gamma. This is a very different tonal response to the way that the human eye (or film) sees images. RAW converters apply gamma correction to RAW images to redistribute the tonal information to match the human eye more closely.

Linearization

Adjustments performed to a **digital** signal to ensure that the **output** from each channel of a device such as **scanner** or printer is linear in relation to a predefined set of values.

Line time

The time taken by a **linear array CCD** to scan across the projected image, and record a single line of pixel data.

Lithium-ion (Li-ion)

Lightweight rechargeable battery with a very high capacity (up to twice that of a NiMH rechargeable battery) and does not suffer from memory effect problems.

Lithium polymer (Li-Po)

The lithium polymer battery represents a new rechargeable type of battery technology that does not need a metal casing. Instead, the electrodes are covered with flexible plastic or aluminium foil. They also have a very high energy **density** enabling them to be smaller but provide higher performance than other rechargeable batteries. Also, they are easier and cheaper to produce in the medium term than **Li-ion** rechargeable batteries but are only available in custom made forms requiring special chargers.

lpi (lines per inch)

The scale used by printers when specifying the **halftone** screen used in a printing process. Typical values for different print media are:

Newsprint	80–100 lpi
Books	133 lpi (including this one)
High end magazine	150–175 lpi
Quality reports/brochures	200–300 lpi

Liquid ink jet

This method of **ink jet printing** propels fine droplets of liquid ink onto the paper surface. This may lead to the ink soaking into the fibres of the paper, and being wet for some time after the print process has finished. This method is generally used in relatively inexpensive **ink jet printers**.

Live Picture®

A largely redundant image processing program which used **FITS** technology, enabling users to manipulate and work with very large images in almost real-time on a relatively small desktop computer. Before processing, images are converted into the **IVUE** format. From this file the program creates a 'view file' at screen resolution (72 dpi) so that even a large image of 100 MB or more will only take up a maximum of 2.2 MB. All processing is carried out on this image, and is performed very quickly, with virtually no delay. As changes are made, a list is compiled in a file known as **FITS**. This list is applied to the on-screen image during editing – the original remains untouched. When completed, the alterations recorded in the FITS file will be applied to the IVUE file, producing a **TIFF** file. This can be generated at a specific resolution, dependent on the **output** device being used. This 'post-processing', or 'building' of the image may take several minutes.

Lossless compression

A **data compression** routine which does not sacrifice data in the process of saving images.
See also **Data compression**

Lossy compression*

A **data compression** routine, such as **JPEG**, which sacrifices data in the process of saving images.
See also **Data compression**

Low end

A term often used to describe imaging systems using relatively inexpensive **scanners**, cameras,
desktop computers and **output** devices. The file sizes handled are usually lower than in '**high end**' systems, and the quality of work may not be good enough for the very highest reproduction requirements. Increasingly, the differences between high end and **low end** systems are becoming smaller.

Low key

An image composed mainly of dark tones.

Low pass filter

A filter which smooths/blurs an image by removing high spatial frequency detail (i.e., sharp edges and detail). This is a typical '**blur**' filter in a program such as **Photoshop**.

Luminance

1. The brightness of a surface emitting or reflecting light.
2. In video, the part of the signal which determines the brightness of an image. Usually denoted as 'Y', as in **YCC**.

Luminance signal (also called the 'Y' signal)

See **Luminance**

LUT (Look-Up Table)

A preset number of colours used by an image (sometimes **CLUT** – colour LUT).

LZW (Lempel-Ziv-Welch)

A **lossless compression** routine developed in the 1970s, and incorporated into the **TIFF** and **GIF file formats**.

Mm

mAh (milliampere-hour)

Unit used to describe the power consumption of electrical equipment or the storage capacity of batteries.

Macbeth®

Manufacturer of colour management tools including the commonly used Macbeth ColorChecker Chart.

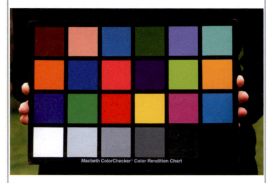

Macbeth ColorChecker Chart: The industry standard chart used to help calibrate imaging devices. Each square is a known value and hue.

Mach band

An optical illusion whereby dark and light bands are seen at the edges of uniformly lit areas of colour or **density**.

Macintosh®

See **Apple**®

Macro

1. Close-up photography usually at magnifications larger than life-size.
2. A small computer program usually accessed by a single keystroke or keyboard combination, which performs a particular task. An example is the actions that can be recorded in **Adobe Photoshop**®.

Magic Wand

A selection **tool** found in image processing programs such as **Adobe Photoshop**® that automatically selects a contiguous area of similarly coloured or toned pixels within a specified tolerance range.

Magnetic Video Camera

See **MAVICA**™

Magneto-optical disc drive

See **MO**

Mandelbrot set

A type of **fractal**.

Mapping

The process of transforming image input brightness into output brightness.

Marching ants

An animated line surrounding a selected area of an image in an image processing program such as **Adobe Photoshop**®.

Markup

Instructions and specifications for material submitted for reproduction or printing.

Marquee

The name given in image processing programs such as **Adobe Photoshop**® to the rectangular, square, elliptical or circular area enclosed by an animated line drawn by selection **tools**.

Mask

To delineate a selected part of an image, so that an effect can be applied either to the selected area, or to the non-selected area.

Matchprint™

A system devised by 3M™ which uses a system of creating four colour (CMYK) separations using the same data that will generate the final printing plate. Each separation is placed on the relevant coloured laminate and the resulting sandwich then exposed to ultra-violet light. The coloured laminate softens when exposed to the light. A process is then applied to remove the softened areas leaving a positive image of each layer constructed of the same dot pattern as the final printed page. The process is applied in turn to the four layers of coloured laminate which are then bound in register and sealed.

Matrix array

See Area array CCD

MAVICA™ (Magnetic Video Camera)

The name given to the first still video camera produced by Sony® in 1981. Up to 50 images in analogue format were recorded onto a 5 cm floppy disc. The name has subsequently been used by Sony® for some of its digital cameras.

Media transfer protocol

See MTP

Median filter

A noise-reduction filter found within image processing programs. The filter searches the radius of a selection of pixels, and replaces the centre pixel with the median brightness value of those around it.

Megapixel

One million pixels.

Memory card

Small storage cards for storing images from digital cameras. There are several different types including CompactFlash®, SmartMedia™ and Memory Stick™.

Memory Stick

A memory card for digital cameras made by Sony®. There are two generations with the Memory Stick Pro™ version having capacities up to 4 GB. The first generation cards are much slower, with capacities only up to 128 MB.

Menu

A drop-down list of computer commands and functions.

Metadata

Literally 'data about data'. Image files contain data such as EXIF metadata, whilst RAW files also contain metadata required by conversion software programs to process the RAW data into RGB images.

Metal oxide semiconductors

See MOS

Metamerism

A visual phenomenon whereby two colours may appear identical under certain lighting conditions, and different under others. Colours exhibiting this feature are known as 'metameric pairs'.

Mexican Hat filter

A filter found in scientific analysis programs which can detect edges, and smooth the image in one operation.

Mezzotint

A screening technique that uses dots that are the same size or larger than conventional screening, but are of random size and frequency. It is usually used for artistic effect. Adobe Photoshop® has the facility for producing mezzotints with a specific filter.

Metadata: Some of the metadata associated with an image displayed in the Photoshop File Browser.

Midtones

The middle range of values within an image; around 50% in **CMYK** and 128 in the **RGB** system.

Millions of instructions per second

See **MIPS**

Mini-CD

75 mm (3 inch) diameter version of the **CD**, capable of storing up to 210 MB of data.

MIPS (millions of instructions per second)

A measure of the processing speed of a computer.

MIRED (micro-reciprocal degree)

See **Colour temperature**

MMC (multimedia card)

The forerunner of the **SD card**. Generally slower and with a smaller maximum capacity.

MO (magneto-optical disc drive)

A disc drive utilising a **laser** beam that is focussed on a minute area of a disc composed of crystalline metal alloy just a few atoms thick. The laser beam heats the spot on the alloy past a critical temperature at which the crystals within the alloy can be re-arranged by a magnetic field. Read and write heads similar to conventional disc drives align the crystals according to the signal being sent.

Mode

Term used in image processing programs such as **Adobe Photoshop**® for the type of image, e.g. **RGB**, **CMYK**, **greyscale**, **duotone**, lab or **indexed colour**.

Modem (MOdulate and DEModulate)

A device used to transmit and receive data using telephone lines. It converts **digital** signals into **analogue** data from the sending computer, and converts analogue data back into digital form for the receiving computer.

Moiré

A repetitive interference pattern caused by overlapping grids of dots or lines having different frequencies or angles. A moiré pattern may result when scanning a screened original. Halftone screens must be set at angles to each other to minimize moiré patterns.

Monitor

The display screen on which computer data is viewed. Many are based on **CRT** technology, but increasingly flat screens using **LCD** technology are becoming common. Important considerations for imaging are the size of the monitor, the number of colours that can be displayed on a monitor (**bit depth**), the sharpness of the image *(spatial resolution)* and the **dot pitch**.

When running digital imaging programs it is assumed that '**photo-realistic**' images are required. Photo-realism is a qualitative term which is used to describe how closely a digital image matches the photographic original. With bit depth, for a photo-realistic display, a minimum of 16 bits (32 768

colours) per pixel (i.e., bit depth) is required, and preferably 24 bit (16.7 million colours) to give photographic quality images, Strictly, the monitor cannot display this number of colours at one time, but it is the number of colours stored in the **LUT**. Typically, it is in images containing areas of graduating intensity (e.g., graduated backgrounds on still-life pack shots) that the difference between 16t and 24 bit becomes apparent. It is believed that at least 160 levels for each of the three colour channels is required to show a continuous gradation without a banding effect (i.e. a 24 bit display).

Morphing

A technique, primarily used in the film industry, for transforming (meta*morpho*sing) one image through a series of steps into another. For example, the film Terminator II showed a blob of molten metal gradually 'morphing' into a human figure.

MOS (metal oxide semiconductors)

Highly efficient light sensitive sensors that can be used in place of **CCDs**.

See **CMOS**

Mosaic colour system

A colour system in which colours are formed by the additive mixing of light from adjacent areas, that are generally too small to be resolved individually by the naked eye. An example is colour television, where all colours are formed by the combination of red, green and blue phosphors.

Motherboard

The main circuit board in a computer which houses the **central processing unit (CPU)**, **RAM** and **ROM** chips and various other components.

Motion Picture Experts Group

See **MPEG**

Mottling

A texture pattern that may sometimes appear after sharpening an image. It is most prevalent in areas of flat tone such as sky.

Mouse

The pointing device attached to the computer for moving the **cursor** around the screen, and selecting items from the menus by means of one or more click switches, as well as other functions.

MOV

The file extension (.mov) for movie files created in Apple Quicktime™.

MPC (multimedia personal computer)

The standard for **multimedia** set by the vendors who joined together to form the Multimedia PC Marketing Council.

MPEG (Motion Picture Experts Group)

Like **JPEG**, an acronym used to identify a standard **compression** routine, used primarily for **digital** video, audio and animation sequences.

MRW

The **RAW file** format (.mrw) generated by Minolta **digital** cameras

MS-DOS®

See **DOS**

MTP (media transfer protocol)

A new protocol developed by Microsoft® for multimedia network players.

Multichannel mode

An image mode within **Adobe Photoshop®** and other imaging programs. It is formed when adding a new **channel** to a greyscale image. Multichannel images use 8 bits per pixel, and are used for

specialized printing purposes such as printing a greyscale image with a **spot colour**.

Multimedia

The combination of various media, e.g. sound, text, graphics, video, still photography, into an integrated package.

Multimedia memory card

See **MMC**

Multimedia personal computer

See **MPC**

Multisession discs

A **CD** written in more than one recording session. Multi-session discs can only be read in a multi-session CD player.

Munsell colour system

A widely used **colour space** model, using the attributes hue, chroma and value. It is based upon human colour perception and the visual differences of the three attributes.

Nn

Native file format

The file format used to save data by specific application programs. For example, **Adobe Photoshop**® uses its own Photoshop format, which slightly compresses data when saving. Native file formats must be used in order to store information regarding layers, etc. and when the data is to be re-read by the same program. They generally should not be used for transferring files into other applications such as desktop publishing programs.

National Television Standards Committee

See **NTSC**

Nearest neighbour

A method of **interpolation** whereby in order to increase resolution, the value of the new pixel is determined by giving it the same value as its nearest neighbour. This is the quickest, but least accurate form of interpolation.

NEF

The **RAW** file format (.nef) generated by Nikon® **digital** cameras.

Netscape™

A **software** application used to locate and display Web pages; a Web browser program.

Network

Two or more computers connected together for the purpose of exchanging data.

Newsgroup

Discussion groups on the **Internet** where subscribers can discuss topics, post questions and send answers to others. An example is PRODIG in the UK, a forum for professional photographers to discuss various **digital** imaging issues.

Newton Rings

The undesirable appearance of colour fringed circles. They may appear in scanned images where the original has not been in close enough contact with the drum or glass platen. They are also common when projecting colour transparencies in glass mounts.

NiCd (Nickel Cadmium battery)

A type of rechargeable battery now largely superseded by the **NiMH** battery.

NiMH (Nickel Metal Hydride battery)

A type of rechargeable battery with 100% higher energy **density** than NiCd batteries and capable of supplying high energy levels when required, e.g. when using electronic flash in quick succession. They can be recharged more than 300 times and are environmentally friendly (free of cadmium and mercury). NiMH batteries are increasingly used to power **digital** cameras.

Node

A computer system which is part of a **network**.

Noise

Random, incorrectly read pixel data or extraneous signal generated by an **imaging sensor**. May be caused by electrical interference, heat from the electrical components or colour rendering problems, and can be likened to the background hiss from a stereo which is set to full volume, but not playing any music. It is most apparent in dark areas of images with long exposures and high ISO values.

Many different types of noise can cause image degradation, but mainly two basic types affect many digital cameras: Random and Fixed pattern noise.

- **Random noise** is generated primarily by heat fluctuations in the electrical components. Its

effect can be greatly reduced where appropriate, through a process of **image averaging.**

- **Fixed pattern noise** results generally from slight variations in the photo sites, thus exhibiting a fixed pattern across the image.

Due to the nature of the **Bayer** pattern on the imaging sensor, noise is most often found in the red and blue **channels** of the image.

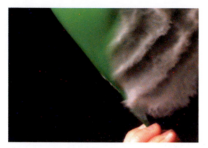

Noise: An example of dark current noise in an image.

Noise filter

A selection of filters found in image processing programs such as **Adobe Photoshop**® which reduce the effects of noise. Some programs also have *add noise* filters which apply random pixels to an image for creative or graphic effects.

See **Median filter**

Non-impact printer

A printing device which prints information onto the receiving surface without coming into contact with it. Examples are **ink jet** and **laser printers**.

Non-interlace scanning

A process used in some high-quality television sets and computer monitors, whereby each scan line is transmitted in sequence, rather than the transmission of odd and even lines in separate scans. This leads generally to sharper images on screen.

See **Interlacing**

Non-volatile memory

See **Flash memory**

NTSC (National Television Standards Committee)

The broadcast TV standard used in the USA and Japan. It specifies 525 lines, 60 fields and 30 frames per second (strictly 29.97 fps).

Nubus

The **bus** used in Apple® Macintosh® computers.

Nyquist criterion

The minimum frequency in which a continuous waveform must be sampled for it to be accurately reconstructed from discrete sampling data. This frequency is greater than twice the maximum frequency present in the **analogue** waveform. If the waveform is sampled at a lower frequency, then the undersampled frequencies will be aliased and the lower frequencies will show distortion.

Oo

Object-oriented

A graphics application such as **Adobe Illustrator**®, which uses mathematical points (bezier points) based on vectors to define lines and shapes in the image.

Object linking and embedding

See **OLE**

OCR (optical character recognition)

Software which when used in conjunction with a **digital** scanner, converts pages of typescript text into editable computer data.

OLE (object linking and embedding)

A system developed by Microsoft® for exchanging data between applications.

OLED (organic light emitting diode)

A technology for image displays, used particularly on the back of digital cameras, based on various organic materials which glow in response to an electrical current.

Opacity

The ratio between the amount of light falling upon a transparent material (such as a **filter**) to that transmitted by it.
See **Density**

Operating system

See **OS**

Optical character recognition

See **OCR**

Optical disc

A disc used for storing **digital** data. The data is written to, and read from the disc by a **laser**. The discs are generally used for large volumes of data.

Optical media

See **Optical disc**

Optical resolution

The 'true' resolution of a scanner, i.e. the actual number of pixels present in the **linear array CCD** chip. The resolution of a scanner can be increased through **interpolation** techniques.

Optical viewfinder

The lens assembly in a camera used for viewing a scene. It may be separate from the lens which takes the image, or combined with it, as in a reflex viewing system.

Optical zoom

A lens with a variable **focal length**, e.g. 24–70 mm.

Organic light emitting diode

See **OLED**

OS (operating system)

A series of computer programs which enable other programs to run on the computer. It creates an environment enabling different programs to perform functions such as saving, printing, displaying lists of stored files and deleting. Without an operating system, each program would need to have these functions built-in. The ability to **cut** and **paste** items between programs is an integral part of the operating system of the computer. Examples are Microsoft® Windows XP®, and Apple® Mac OSX®.

ORF (Olympus RAW format)

The **RAW** file format (.orf) generated by Olympus **digital** cameras.

96 Output

The way in which a **digital** image (or other digital file) is viewed. Examples are reproductions in books and magazines, ink jet and dye sublimation prints, and projection and **monitor** displays.

Overscanning

The capture of more grey tones or colours than is actually required for the particular **output** device to be used. The additional data can be used to increase the highlight or shadow detail.

Pp

Page description language
See **PDL**

Paint
A program that defines images in terms of **bitmaps** rather than vectors.

PAL (phase alternation line)
The TV standard used in the UK and much of Western Europe. It uses 625 lines with 50 fields per second. Of the 625 lines transmitted, 576 are used for the pictures signal, and 49 are used for other data such as teletext and control signals.

Palette
A range of colours, tones, or image processing tools.

Panorama
1. A single image captured by a specialist camera with an extreme wide angle lens.
2. A series of images joined together (stitched) in a computer program.

Panoramic images are generally those where a number of overlapping images have been stitched together to form one continuous image, usually for landscape work (Figures 1–3). Several specific software programs are available to join images together seamlessly, such as PhotoVista® and PhotoStitch®. Image processing programs such as **Adobe Photoshop**® also often have this facility – Photoshop has the Photomerge facility (File > Automate > Photomerge).

When shooting images for panoramas it is essential to keep the camera level, preferably using a tripod with a spirit level. The images should overlap by at least 25%, and to avoid **density** changes across the panorama, the exposure for each frame should be kept constant – use manual exposure mode, and meter from an 'average' part of the scene. Use a standard or wide angle lens, particularly if you intend to produce a very wide panorama of more than 180°. The camera can be rotated to shoot vertically, to give a taller final image.

Original sequence of images

Screen from **Adobe Photoshop**® CS showing Photomerge dialog box. Note the overlap between the two images in the main window, and the third image at the top ready for adding to the panorama.

Final composition

Pantone®

A widely used colour reference system.

See **PMS**

Parallax

The difference in viewpoint between a viewfinder lens and the lens which records the image. It is a particular problem with compact types of camera where the viewfinder and the photographing lens are different. Digital compact cameras have **LCD** displays which can be used to eliminate the problem.

Parallel port

The parallel port socket in computers is often referred to as the *Centronics port* and is most

often used for connecting to printers. Parallel ports have eight parallel wires that send 8 bits (1 byte) of information simultaneously, in the same amount of time that it takes the serial port to send one. One drawback with the system is that of *crosstalk* where voltages leak from one line to another, causing interference of the signal. For this reason the length of parallel cables is limited to approximately 10 ft (3 m).

Parity

A form of error checking when transmitting data.

Passive matrix display

In this type of **LCD** display, relatively few electrodes are used along the liquid crystal layer. The charges fade rapidly, leading to de-saturated colours.

Paste

To take an item held in the computer memory and place it into another file or another part of the original file.

Path

A path is any line or curve drawn using the pen **tool** in programs such as **Adobe Photoshop**®. This tool can be used to draw smooth edged paths, define areas to fill or draw complex shapes. A path is composed of a number of points linked together by straight lines. These lines can be curved into any shape by means of anchor points.

See **Clipping path**

PC (personal computer)

A general term applied to any desktop computer. Often used to distinguish **IBM**™ **compatible** computers from **Apple Macintosh**™ computers.

PC lens (perspective control)

A lens for an SLR type camera with a tilt/shift facility enabling the correction of converging verticals, for example.

PCD

See **PhotoCD**

PCM (pulse code modulation)

A technique for digitizing sound into **binary** code by sampling.

PCMCIA card (Personal Computer Memory Card International Association)

An association formed in 1989 to establish worldwide standards for credit-card sized memory devices. Various types are available including Types I, II and III. These removable cards can contain memory chips, **hard discs**, networking capabilities and **modems**. Sometimes shortened to PC card.

PCX

The native file format for PC Paintbrush™, a paint program used with **DOS**.

PDF

This is a **PostScript**® based file format developed by Adobe for its Acrobat™ software, which preserves text, graphics and formatting of the original document. Thus any document in PDF format can be viewed, using Acrobat reader software on any computer platform, in its original form. Acrobat Distiller™ and other similar programs are required to produce the format.

See **PDF**

PDL (page description language)

A set of instructions which relays to the **output** device, information relating to the placement of images, text and other data, e.g., PostScript®.

PEL

Old, now generally unused term for pixel.

Peltier element

See **Dark current**

Pen tool

Tool found in image processing programs such as **Adobe Photoshop**® for creating **paths**.

Pentium

The name given to the range of microprocessors from Intel® following the 486 series.

Perceptual rendering

Rendering intent which aims to preserve the visual relationship between colours in a way that is perceived as natural to the human eye, although the colour values may be altered. This intent is most suitable for photographic images.

Peripheral

A device such as a **scanner** or **card reader** attached to the computer.

Personal computer

See **PC**

Phase change ink jet

This type of **ink jet printer** uses solid ink sticks, rather than liquid reservoirs. It is a two-phase process. First, the solid ink is melted and then it is sprayed onto the paper in the appropriate pattern. The ink re-solidifies as soon as it hits the paper. This gives excellent quality on a wide variety of paper weights, surfaces, and sizes up to A3.

Phosphor

The substance on a television or computer monitor that glows when struck by an electron beam. In colour systems there are three phosphors, one each for the red, green and blue colours.

PhotoCD

A largely redundant system developed by Kodak® for storing **digital**, high resolution images originally recorded on silver-based film by transfer to **compact disc**. The film images are scanned using a **PIW (photo-imaging workstation)**, and several different versions of each are made. In the case of the Master disc (for 35 mm only) five versions are made (*see* **base resolution**). PhotoCDs can be viewed on **analogue** television systems using a dedicated PhotoCD player or accessed through the **CD ROM** drive on a computer system.

See **PCD**

Photodiode

A light sensitive photocell on a **CCD** or **CMOS** sensor which generates a voltage in proportion to the amount of light falling upon it.

Photography

Literally, from the Greek, *painting with light*. Generally, the term refers to the recording of images onto a light sensitive silver halide emulsion that is coated onto a glass, plastic or paper base, which may then be processed to produce a visible image.

Photo imaging workstation

See **PIW**

Photomechanical reproduction

The reproduction of images, text and graphics using a combination of photographic and mechanical printing processes.

Photomultiplier tube (PMT)

The **imaging sensor** used in high end **drum scanners**. They consist of an evacuated glass tube containing a light sensor (photocathode). Electrons released from the photocathode are multiplied by a

process known as secondary emission. An **analogue** electrical signal is generated in proportion to the light received. This is converted by an **ADC** into a digital data stream.

Photo-realistic

A display which shows photographic quality images. When applied to computer monitors it generally refers to 24 bit displays.

Photosensitive

Property of a material which undergoes a physical change due to the action of radiation, particularly light. The term encompasses fabric dyes, which may fade, photographic materials and electronic sensing devices such as video tubes and **CCD** sensors.

Photoshop™

An image processing program by **Adobe**, which has become the *de facto* standard for desktop image processing.
See also **Native file format**

Photosite

Alternative term for the **picture element** or **pixels** on a **CCD** chip.
See **Pixel**

PIC

A standard image file format used for animation files.

Pick-up device

A camera tube or solid state image sensor that converts incident light on its target into a corresponding electrical **analogue** signal. Solid state devices use a matrix of minute photo-sensitive cells such as a **CCD** sensor.

PICT

The name given to **Apple**'s internal **binary** format for a black and white image in vector or

bitmap image. A PICT image can be directly displayed on a Macintosh screen or printed. The resolution is relatively low, and the images cannot be scaled to another size without loss of detail.

PICT 2

A variant of the **PICT** format, used for describing 32 bit colour data files.

PictBridge

An industry standard system for printing images directly from **digital** cameras without using a computer.

Pictrography™

A system of printing developed by Fuji® which uses **laser** technology to beam the image onto a chemically impregnated donor sheet inside the machine. Red, green and blue lasers are used to form the image on the surface of the donor material which is then brought into contact with the paper surface and heated. The activating element in the system is a small amount of distilled water which is removed by the heating process. The used donor sheet remains in the case of the printer and as the process uses a silver halide based system, the silver can be recovered from the donor sheets.

Pictrostat®

A print produced by the **Pictrography**™ system.

PictureCD

The Kodak® system of digitizing colour negatives and storing them on **CDs** or **floppy discs**.

Picture element

See **Pixel**

Picture transfer protocol

See **PTP**

Piezoelectric

A process using oscillations of electrically stimulated piezoelectric crystals to force ink through inkjet nozzles onto printing paper.

Pigment

A colourant that cannot be dissolved in a liquid. Pigmentbased inks are being increasingly used in **ink jet printers** for greater stability and longevity.

PIM (Print Image Matching technology)

A system developed by Epson® for the production of digital photo prints on desktop **ink jet printers**. Information about colour and other relevant data (such as light values, colour saturation, colour balance, contrast, etc.) are recorded in the *Exif* file header and can then be used by PIM compatible printers when printing.

Pin cushion distortion

A lens distortion which causes the image of a square to appear pin-cushion shaped.

Pit

The minute indentations in the surface of a **compact disc**.

PIW (photo imaging workstation)

The unit manufactured by Kodak® for the production of **PhotoCDs.** They consist of a **scanner**, computer and **thermal dye sublimation printer** for the production of the **index prints**.

Pixel*

The term derived from **picture element**, usually taken to mean the smallest area capable of resolving detail in an **imaging sensor** such as a **CCD array**. An **area array CCD** in a digital camera may have 3000 pixels horizontally by 2000 vertically, giving a total of 6 million pixels. A single pixel in a digital image will have both a colour value and a **density** value.

In most current systems, pixels are square, but occasionally, pixels may be rectangular, round or even triangular. If an image with rectangular pixels is transferred into a program using square pixels, the aspect ratios of the image will be different, and a correction factor will need to be applied. For example, if the rectangular pixels have an aspect ratio of 2:1, the image will need to be stretched horizontally by 200 per cent to retain the proportions of the original image.

Pixel-based editing

A feature of image processing programs such as **Adobe Photoshop**®, which use **bitmaps** for display and processing of images. Any change made to the image is done by changing the values of individual pixels within the bitmap.

Pixel cloning

See **Cloning**

Pixellation

A subjective impairment of the image in which the pixels are large enough to be individually visible.

Pixel mapping

A feature in many digital cameras where the **imaging sensor** and image processing functions can be checked and adjusted. It is used to identify *dead* pixels and replace their data with data from adjoining pixels.

Pixel skipping

A means of reducing image resolution by deleting pixels.

Pixels per inch

See **PPI**

Plasma display

A type of television display using a gas which glows when an electrical current passes through it.

Platform

The type of computer system, e.g. Apple® or IBM® PC compatible.

Plug and play

The facility provided with computer **operating systems** of being able to plug in a new peripheral device, or board, and not having to go through a configuration routine.

Plug-in

A small piece of software often supplied with **scanners** and other peripherals allowing the user to access and control those devices through an image processing software package such as **Adobe Photoshop**®. Many third party manufacturers (such as Extensis® and AlienSkin®) market plug-ins designed to increase the range of **filters** available or to perform specific tasks such as re-sampling or advanced sharpening. When installed, the plug-in becomes an item on one of the program's menus. *See* **Driver**.

PMS (Pantone® Matching System)

An industry standard for defining the colour composition of mixed inks. PMS gives the formula for mixing ink colours. Particular colours are given a number, e.g. PMS 285-1 is a deep green colour.

PMT

See **Photo multiplier tube**

PNG (portable network graphics)

A file format for web graphics deigned primarily as a replacement for the **GIF** format. There are two basic types, PNG 24 and PNG 8, for 24 and 8 bit images, which allow for **lossless compression**. Transparency can be incorporated using **alpha channels**.

Point processing

An image processing operation which operates on single **pixels**, e.g. pixel counting.

Pointing device

In computers, the device attached to the computer which controls the movement of a **cursor** on the screen, e.g. a **mouse**, **stylus** or **trackball**.

Portable network graphics

See **PNG**

POP

1. **Point of presence**

 The location of an **Internet** service provider. It is important when choosing a provider to choose one that is a local telephone call away.

2. **Post-office protocol**

 Refers to the way **email software** such as Eudora™ gets mail from the mail server.

Portable Document Format

See **PDF**

Posterization

Traditionally, a photographic printing method of reducing a continuous tone monochrome or colour image to a predetermined number of tones, each of which is a uniform tone or colour value. Typical posterizations will have between three to five tones. Image processing programs usually have the facility for producing posterized images. Stretching the tones of an image histogram excessively may cause a posterized (or **banding**) effect.

Post-processing

The process of applying all the changes and alterations made to an image in programs such as LivePicture at the end of the manipulation stage.

PostScript®

A **page description language (PDL)** developed by Adobe Systems to simulate the operations of printing, including placing and sizing text, drawing and painting, graphics, and preparing halftones from digitized greyscale images. It consists of a set

Posterization: An image posterized to eight levels. Note in particular the smoothly graduated sky in the original below becomes three flat tones in the Posterized image.

of software commands and protocols that form images on output devices when translated through a **Raster Image Processor (RIP)**. It is 'device independent', allowing output devices of differing types and manufacturers to print the same file in the same way. It has become a standard way of 'driving' high quality printers. The original version was called Level 1. The later Level 2 incorporated definitions for **colour space** and for colour **data compression**.

PostScript Printer Description file
See **PPD**

PowerPoint®
A 'presentation graphics' program within the Microsoft Office™ suite, for making **digital** 'slide shows'. It is often used for projecting images as a slide show, or within a lecture. Images for PowerPoint must use the same criteria as those for *Web* sites – use a resolution of 72 ppi, and re-size the image to the size it will appear on screen, e.g. 800 pixels wide.

PPD (PostScript Printer Description file)
A file specifying the characteristics of an output device.

PPI (pixels per inch)
The standard unit of measurement of resolution for scanned images.

Pre-flighting
The simulation of printed **output** on a computer **monitor**. Instead of a **hardware RIP** (in printers) a **software RIP** is used so that any potential problems can be seen on the screen saving ink and paper.

Primary colours
The three primary colours of light are red, green and blue.

Print Image Matching technology
See **PIM**

Process colours
The four process colours are cyan, magenta, yellow and black.

Process Inks
The four specific inks used in the four colour printing process: cyan, magenta, yellow and black.

Profile
The characteristics (usually colour and contrast) of a device such as a printer or **scanner**, or of film. Used by **colour management systems** to ensure colour consistency throughout the printing process. The industry standard is the ICC profiles, recognized by various colour management programs.

Program

The application software used by computers.

Prompt

A symbol or character on the computer monitor indicating that the computer is waiting for an instruction.

Proof

A representation of how an image will finally appear when printed. Several proofing devices are available such as Cromalin™, Approval™ and Matchprint™.

Pro-PhotoCD

The **PhotoCD** format which contains **Image Pac** files from 64 Base to Base/16, which range in size from 72 MB to 72 KB. It is used for film originals up to 5 x 4 in. in size.

Protocol

A set of defined rules for the exchange of **digital** data, which allows communication between computer systems.

Proxy

A low resolution version of an image file being processed. When the various operations have been completed, they can then be applied to a higher resolution version.

Pseudo-colouring

The process of either adding colour, or modifying the colours of an image. In the case of greyscale images, particular grey tones can be assigned specific colours.

PTP (picture transfer protocol)

An image data transfer protocol (similar to the *TCP/IP* protocol for the **Internet**) that is intended to do away with the need for specific camera drivers. PTP compatible devices, such as digital cameras, computers, mobile phones and printers, should be able to transfer data without the need for special software drivers.

Public domain

Software which is free to use.

Pull-down/pop-up

A menu which appears when the main menu title is clicked at the top of the screen.

Pulse code modulation

See **PCM**

Qq

'Q' factor (quality factor, sometimes called 'halftoning factor')

A multiplication factor used to calculate the scanning resolution for optimum output quality. The quality or halftoning factor is used in the printing industry for determining the optimum result when digital images are printed using line screens. The resolution of a digital image is defined in 'pixels per inch' **(ppi)**, whilst halftone printers conventionally use 'lines per inch' (lpi). The Q factor can be used to determine which ratio of ppi to lpi gives optimum results when printed:

less than 1:1 (ppi < lpi):

If less than one pixel per line is used, the image will display **pixellation** and the software will need to **interpolate** pixels to generate information. The user has no control over this process and the end result is dependent on the software's interpolation capabilities. If a smaller file has to be used, the best compromise is to resample the image in an image processing program such as Photoshop, which allows the user to choose the interpolation method (**bicubic**, **nearest neighbour**, etc.) and examine the result prior to printing.

1:1 (ppi = lpi)

If the number of pixels matches the number of lines, the resulting image may exhibit **artefacts** such as **aliasing** introduced by the screening angles used to avoid **moiré** patterns. It is necessary therefore that the pixels per inch be greater than lines per inch.

1.25–2.0:1 (ppi > lpi)

The standard 'rule of thumb' used by the majority of the print industry is to supply *twice as many pixels as lines* (i.e. a file would be supplied at 300 ppi for a magazine or book being printed with a line screen of 150 lpi). This figure is worth testing, however, with ratios between 1.25 and 2:1, and it

may well be found that there is no perceptible difference between them. Using smaller file sizes may lead to a saving in both time and material cost.

2–2.5:1 (ppi > lpi)

The extra information supplied at ratios of 2:1 or greater gives no perceptible improvement in quality. In ratios of over 2.5:1 the **PostScript RIP** conversion process entirely ignores the information.

By experimentation, a Q factor can be found within the region of 1.25–2:1. However, the following guidelines can be used as a basis for further experimentation:

- Q values from 1.25 to 2.0 work well for **halftone** dot images
- Q value of 2 can be chosen for screen rulings of 133 lpi or less
- Q value of 1.5 works well for screen rulings greater than 133 lpi
- Q values over 2 are wasteful, leading to large file sizes

With the advent of new screening processes such as **stochastic (FM – frequency modulated) screening**, lower pixel resolutions are possible, with the Q factor falling as low as 1:1.

Quadtone

See **Duotone**

Quantization

The process of converting **analogue** brightness into discrete **digital** values.

QuarkXpress®

An industry standard **desktop publishing** program for **Apple Macintosh**® and **IBM**® PC compatible computers.

Quartertone

Tonal values roughly in the region of 25 per cent.

108 QuickDraw®

Part of the **Apple Macintosh**® **operating system** which handles screen display and other graphical functions.

QuickMask

A specific masking function found in **Adobe Photoshop**®. A selected area can be instantly converted into 'QuickMask mode', which can be saved as a separate channel. The mask can then be modified with paint brushes, for example.

QuickTime®

An extension to the Macintosh **operating system** developed by **Apple**® for storing video and animation. It incorporates video compression technology.

QXGA (Quad Extended Graphics Array)

A standard for displaying images on a screen. Typical resolution is 2048 × 1536 pixels.

Rr

RAF

The **RAW** file format (.raf) generated by Fuji® digital cameras.

RAID (redundant array of independent discs)

A high end storage system using a number of connected hard drives. The basic idea is to use two or more drives which are combined into a single logical drive. Data is written onto the drives in sequence. Various levels of RAID exist, and in its most sophisticated form, the data is error checked as it is written. The system offers very fast writing and retrieval. In some cases, should one of the drives fail, it can be replaced without loss of data, and without shutting down the system. Several major picture libraries use the system for archival storage of their images.

RAM (random access memory)

Temporary memory created and used only when the computer is switched on. The size of images which can be opened is dependent on how much RAM is installed in the computer.

Random access

The ability to access stored information directly, rather than having to go through all the previously stored data.

Raster

A series of scanning lines in a pattern which provides uniform coverage of a subject or image area. The number and length of the lines are related to spatial resolution.

Raster graphic

A graphic image, created by **scanners**, **digital cameras** or **paint** programs, whose components are individual **pixels**.

Raster image processor

See **RIP**

Rasterize

The conversion of mathematically defined points in **object oriented** drawing packages, or the data contained in a **FITS** file in **Live Picture**®, into *pixels* for output to a printing device.

Raster unit

In electronic imaging, the distance between the mid points of two adjacent pixels.

RAW

A RAW file is a record of the unprocessed data captured by an **imaging sensor**. The RAW file format is the data from the imaging sensor saved as a file, without any in-camera processing or compression. It is the equivalent of the film camera negative. Different camera manufacturers have their own RAW files, for example, Canon® files are known as CRW, whilst Nikon® files are NEF. Because of this, and the potential problem with long term archiving and retrieval of RAW files, Adobe launched a new format in 2004 called **DNG** (Digital Negative), which retains the original, unprocessed nature of the file, but which will hopefully become universally accepted within the industry.

To access RAW files, you can use the camera manufacturers' software, e.g., Nikon View, third party programs such as BreezeBrowser® or imaging programs such as **Adobe Photoshop**® version CS.

RAW files contain two types of information – image pixels and image **metadata**, such as **EXIF** data, which records information about the exposure, focal length of lens, date/time and so on. They also include the additional metadata that the RAW converter needs in order to process the RAW data into an **RGB** image. There is a greyscale value for each **pixel**, together with information

conveying to the RAW converter the pattern of colour filters on the sensor, so that it can assign the 'correct' colour to each pixel. The RAW converter uses this metadata to convert the greyscale information into a colour image by interpolating the colour information for each pixel from its neighbours. RAW converters need specific information about each camera model in order to process the images. The process is known as 'demosaicing'. RAW converters also perform other tasks to deal with white balance, gamma correction, noise reduction and sharpening. Different RAW converters could give different interpretations of the same file.

A RAW file can be compared to an unprocessed roll of film, where the photographer can choose which developer to use, the length of time to develop, etc. In this case, if the first result is unacceptable, it is possible to go back and reprocess the image unlike **TIFF** and **JPEG** files that already have processing algorithms applied to them and where it is not possible to reprocess them if necessary.

The dialog box from Adobe Photoshop® CS: Shows the RAW file from a Kodak 14n 14 megapixel **DSLR** camera. The fields at the bottom left show image resolution, **bit depth**, colour space and pixel dimensions. To the right of the image are slider controls for altering the colour temperature, exposure and other settings. The coloured **histogram** can be used to help with adjusting colour balance of the image. After opening the image in Photoshop, it must be saved as a TIFF (or other) file so that the original RAW file remains untouched as an archive record.

Screen shot of Adobe DNG (Digital Negative Converter): Software used for archiving RAW camera files.

Read

In computing, to access data from a disc, tape or memory, and display it on a screen.

Read only memory

See **ROM**

Real-time

Refers to computer operations which occur immediately.

Recomposition

The term used to describe the generation of the higher resolution images within a **PhotoCD Image Pac**.

Receptor

General term used for a substance on which radiation such as light falls, and which responds to that radiation, e.g. photoreceptors, photocell and the retina of the eye.

Reflective copy

Photographic print or other media viewed by reflected light.

Reflex

A type of viewing system in cameras such as **digital single lens reflex (DSLRs)** where the subject is viewed through a mirror and prism

assembly, instead of through the actual lens, which captures the image.

Refresh rate

The time taken for a computer **monitor** to update the information on the screen.

Register marks

Small marks printed alongside artwork and images, which are superimposed during printing to ensure that the printing plates are in register.

Registration

1. The superimposition of image separations so that they overlay precisely.
2. To agree to abide by the conditions of the licensing agreement supplied with a piece of software. Only registered users of software are entitled to upgrades.

RHEM® strip

Small, self-adhesive labels printed with two types of ink, which can be attached to proof prints for approval by clients, used to verify the lighting conditions under which the print is viewed. Under standard lighting (5000 K or **D50**) the difference in colour between the strips will not be visible. However, under other lighting (e.g. tungsten), the strips can be clearly seen, indicating that the viewing conditions are not appropriate.

REHM strip: A small self-adhesive strip which can be applied to prints to see if the viewing light is 5000 K.

Rel (recorder elements per inch)

The minimum distance between two recorded points in an **imagesetter**.

Relative colorimetric rendering

This rendering intent is similar to absolute colorimetric except that it compares the white point (extreme highlight) of the source **colour space** to that of the destination colour space and shifts all colours accordingly. It is commonly used for illustrations rather than images.

Remote sensing

The capturing of an image from a remote source – usually applied to satellite imaging.

Render

Applying a surface texture to a two or three dimensional **wireframe** surface or shape drawn in a computer graphics program to produce a realistic effect.

Rendering intent

The various methods used for converting colours from one colour space into another. The rendering intents are a standard part of the **ICC profile** format. There are four methods called **perceptual**, **saturation**, **relative colorimetric** and **absolute colorimetric** (the names may differ from one system to another).

Replication

A form of image **resampling** where the exact colours of neighbouring pixels are copied. This should only be used when doubling or quadrupling resolution i.e. 200, 400, 800 per cent, etc.

Reproduction gamma

The relative contrast of the **midtones** of a printed reproduction of an image compared to the original. Adjusting the **gamma** using the **curves** control allows the user to modify the contrast of the midtones without affecting the shadow or highlight tones.

Reproduction rights

The right, arising from ownership of copyright of an image, that allows the making of copies in any medium. The copyright owner may license others to reproduce the image usually for a specific purpose, size and market.

Res

A metric term used in place of **ppi** to define image resolution. Res 12 equals 12 pixels per millimetre (305 ppi).

Resampling

Changing the resolution of an image, either by discarding unwanted pixels, or interpolating new ones.

See **Interpolation**

Resizing

Changing the size of an image without altering the resolution. Increasing the size will lead to a decrease in image quality.

Resolution (brightness)

This refers to the number of bits of stored information per pixel.

See **Bit depth**

Resolution (spatial)

The ability of a recording system to record and reproduce fine detail. In digital imaging, the resolution of the final image is dependent upon the resolution of the image capture device (camera, **scanner**, etc.), any change made during image processing by computer and the resolution of the output device. The term 'image resolution' refers to the number of **pixels** within an image, and is measured in **pixels per inch**. An image recorded with a Nikon D100® camera, for example, has 3008 × 2000 pixels – over 6 million pixels in total. Because the number of pixels within an image is fixed,

increasing or decreasing the image size **(resampling)** will alter the resolution. Increasing the size will cause a decrease in the resolution. Image processing programs such as **Adobe Photoshop**® have the facility to both resize and resample the image.

When looking at the resolution of imaging devices, in particular scanners, it is important to distinguish between **optical resolution** i.e. the actual number of pixels on the sensor, and higher resolution created by the process of **interpolation**. A scanner may be advertised as having a resolution of 1200 dpi, where in actual fact it has an optical resolution of 600 dpi, interpolated to 1200 dpi by the scanning software.

Video resolution is given as lines per picture height, e.g. 625 lines. **CRT** resolutions are usually given as number of pixels per scan line, and the number of scan lines, e.g. 640 × 480 **(NTSC)**, 768 x 512 **(PAL)**. Printer resolutions are usually given as dots per inch, e.g. 300 dpi.

Resolving power

The ability of an optical imaging system to record fine detail, usually measured by its ability to maintain separation between close subject elements such as fine lines (usually quoted as 'line pairs per millimetre').

RIFF

Raster Image File Format

An image file format for greyscale images. Has the chief advantage of offering significant disc space savings by using **data compression** techniques. Letraset's proprietary alternative to **TIFF**. Stores up to 32 bit information, but only used with Letraset® programs such as Color Studio™.

Resource Interchange File Format

A file format for multimedia which allows graphics, sound, animation and other data to be stored in a common, cross-platform form.

RIP (raster image processor)

A device which converts a page description language (PDL) such as Postscript® into the raster form necessary for output by an **imagesetter**, **film recorder** or **laser printer**.

RISC (reduced instruction set computing)

A modern microprocessor chip that works faster than previous versions by processing fewer instructions.

RGB (red, green, blue)

The three primary colours used in **monitor** displays.

RGBE

The pattern of coloured filters on some Sony® **imaging sensors**, which uses a pattern of Red, Green, Blue and Emerald (Cyan), rather than the common **Bayer pattern**. It is designed to closely replicate colours as perceived by the human eye.

RLE (run length encoding)

See **Huffman encoding**

ROM (read only memory)

A memory unit in which the data is stored permanently. The information is read out non-destructively, and no information can be written into memory. It resides in special chips on the motherboard of the computer, and is where the **firmware** is kept.

Rosette

To prevent **moiré** patterns when printing with **CMYK** separations, the **halftone** screens are placed at different angles to each other. They form interference patterns known as rosettes.

Royalty free images

Collections of images which are sold, and can then be used for a wide variety of publication purposes without further payment of royalties. The copyright of the images remains with the original owner. Sometimes referred to as **photographic clip-art.**

RS232

The designation by the Electronics Industries Association for the industry 'standard' for **serial ports** in computers. The standard is not completely used however, and several different connectors are used.

Rubber stamp

See **Cloning tool**

RUN

In some computer systems such as **DOS**, the instruction given to start the execution of a programmed task.

Run length encoding (RLE)

See **Huffman encoding**

Ss

Samples per inch (spi)

Same as **pixels per inch**

Sampling

The process of converting time into discrete values.

Saturation

The strength or purity of a colour.
See **HSB**

Saturation rendering

The intent that preserves the saturation of out of gamut colours at the expense of hue and lightness. This is the best intent for use when dealing with graphical images.

Save

To write a new version of a file over the old version.

Save As...

To save a new version of a file with the opportunity of giving it a new filename.

Scale of reproduction

The degree of enlargement or reduction of a reproduced image. Usually quoted as a percentage.

Scaling

The process of enlarging or reducing the size of an image for reproduction.

Scan back

A **linear** (or **tri-linear**) **array CCD** placed in the focal plane of a camera (usually a medium or large format film camera body) to scan the image projected by the lens.
See **Digital camera**

Scanner

Any device which converts artwork, photographs or text into digital data. Until relatively recently most scanning for professional use was carried out by experienced operators using **drum scanners**. Today, desktop **flatbed** and **film scanners** have become good enough for many professional applications, and cheap enough for many photographers to own them. There are several types, classified according to the type of original to be scanned, and the method of operation.

Film scanners, as the name implies are designed for scanning colour transparency or negative film. A good film scanner needs to have a **dynamic range** of at least 4.0, and ideally a resolution of at least 4000 dpi* with 35 mm film. This would enable an A4 reproduction in a glossy magazine when printed with a line screen of 150 lpi.

Flatbed scanners can operate in two modes, either reflective, where the light source is reflected from the surface of the item being scanned, or transmissive, where the light is transmitted through the object, perhaps a negative or transparency.

Typical film scanner for 35 mm originals.

*NB: As noted elsewhere it is traditional for scanner manufacturers to define resolution in dpi (dots per inch). This equates to ppi (pixels per inch).

Screen capture of film scanner software. Notice the scan resolution (5400 dpi) and final file size (198.4 MB – image is to be scanned in 16 bit mode). A software utility called Digital Ice has been selected, to automatically reduce the effect of dust and scratches. The preview has been cropped slightly before the final scan is made.

Screen capture of flatbed scanner software. Note the scan resolution (600 dpi) and bit depth (48–16 bits per channel), and final image size at bottom right – 121.59 MB. Note too that the unsharp mask is turned off – it is usually best to perform sharpening at the end of the workflow.

Typical flatbed scanner for both reflective and transparent subjects.

Many adjustments can be made at the scanning stage, including manipulation of the image histogram.

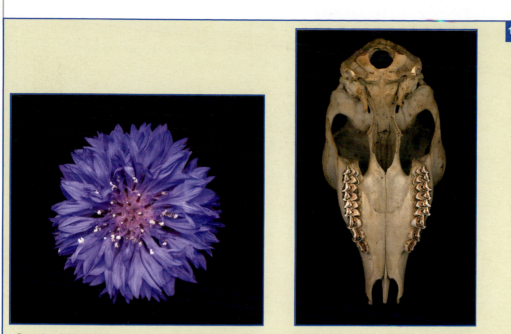

Examples of objects placed on scanner platen and scanned. In both cases the lid was left open to avoid damaging the object, resulting in a black background.

Most scanners can scan in 8, 12 and sometime 16 bits per pixel, the higher **bit depth** giving a wider tonal range for enhancement.

Scanning 3D objects

Any three dimensional object which fits onto the scanner platen can be scanned, and because the light source scans the object, the final lighting is very even across the object. If the object is not flat the scanner lid will need to be left open during the scan.

Scanning

1. The horizontal and vertical movement of the electron beam in a **cathode ray tube**.
2. The process of converting **analogue** image data into **digital** data by means of a scanner.

Scanning line

A line scanned by an electron beam to gather information necessary to reproduce the image. The more lines used, the better the reproduction.

Scan resolution

The resolution at which an original is scanned. Usually quoted in **pixels per inch (ppi)**, **samples per inch (spi)**, or **Res (pixels per millimetre)**.

Scene mode

Various automatic exposure modes on **digital cameras**, which can used according to the subject being photographed. For example, the 'landscape' mode which maximizes depth of field, the 'portrait' mode, which gives smaller depth of field, the 'action' mode which selects fast shutter speeds to

freeze movement and the 'night scene' mode, which balances a burst of fill in flash with a long exposure for the background.

Scratch disc

A reserved area of a **hard disc** used for temporarily storing a copy of the image being processed.

Screen

1. The part of the computer monitor or television on which data is displayed.
2. The **halftone** pattern used by printers to enable images to be printed by photomechanical reproduction.

Screen angle

The term referring to the angle at which two or more **halftone** screens are positioned to minimize undesirable dot patterns.

Screen dump

Where a whole or part of a screen image, including **menus**, tools, background, etc. is printed or saved as a file. The illustrations of the histograms in this book, for example, are screen dumps from **Adobe Photoshop**®.

Screen frequency (Screen ruling)

The resolution of a **halftone** screen, in lines (or dots) per inch. Typical values for different paper types used in the print industry are as follows:

Newsprint	80–100 lpi
Books	133 lpi
Magazines	150–175 lpi
Quality Reports	200–300 lpi

Scrolling

To move the contents of a window vertically or horizontally so that the part of a document hidden by the edges of the window can be viewed.

Scitex® CT (Continuous Tone)

File Format used to export files that can be read directly by Scitex workstations.

SCSI (small computer systems interface)

A communications port used to connect the computer and **peripheral** devices, such as **scanners** or external **hard discs**. Up to six extra SCSI devices can be connected to the computer. They are linked or daisy-chained together, with each device being assigned a specific identity number. The SCSI system has largely been replaced by the smaller and cheaper **USB** connection system.

Secure Digital (SD) card

A **memory card** for digital cameras that is becoming a widely accepted standard. It is based on the **MMC** standard, but is faster and has a higher maximum capacity, currently up to 1 GB. A new development is an SD card with a hinged portion, which when flipped up converts the card into a **USB 2.0** Flash Drive.

SECAM (SEquential Couleur Avec Mémoire)

The colour television standard used in France and most Eastern European countries. Sequential lines are scanned instead of alternate lines as in **PAL**.

Seek time

The time taken to access data from a disc (same as **access time**).

Selection

The portion of an image designated for processing. When a selection is made in an image processing program, the selected area is often delineated by an animated line often referred to as **marching ants**.

Semiconductor

A crystalline material, the resistivity of which is between that of an insulator and a conductor. Semiconductors are used in the manufacture of **integrated circuits** including **CCD**s.

Separation

The process of producing the four files (cyan, magenta, yellow and black) comprising the colour image to be printed.

Serial Port

A multi-purpose port for connecting mice, **modems** and other devices to the computer. The basic principle of the serial port is to have one line to send data, another to receive it and several others to regulate its flow. The data is sent in series, i.e. one bit at a time. This is somewhat inefficient, but no problem for communicating with device like mice, which don't require speed, and for modems connected to standard telephone lines which can only handle one signal at a time.

See **RS232**

Server

A computer or computer program which provides a specific service to 'client' software running on computers connected to it.

Session

A single continuous recording of data to a **CD ROM**.

See **Multi-session**

SGML (Standard Generalised Markup Language)

A set of standards used for tagging the various elements of an electronic document in order to facilitate its production in various media.

Shadow

The darkest values in an image – 75–100 per cent in **CMYK** or 64–0 in **RGB**.

Shadow mask

A perforated metal mask physically separated from the mosaic of red, green and blue phosphor dots on the inner surface of the **CRT**. It directs the passage of the three electron beams passing through it so that they strike their corresponding colour emitting phosphor.

Shareware

Software which is freely available, but which must be paid for if the user decides to continue using it.

Sharpness

A subjective term relating to the perceived quality of an image, largely determined by resolution and **acutance** factors.

Shift register

A series of electronic circuits capable of storing and transmitting the electrical charge out of the **photosites** so that they can be sequentially read by an **ADC**. They are used in **CCD**s to store the electrical charge created by the light falling on the picture elements.

Shutter lag

The time delay, usually on compact type **digital cameras**, between pressing the shutter and the image actually being captured.

Sidecar file

Small files containing the metadata associated with images.

Signal

A general term for any input into an imaging or other system that causes an appropriate action with respect to **output**.

120 **Signal to noise ratio** (*S/N*)

The relationship between the required electrical signal to the unwanted signals caused by interference [usually measured in decibels (dB)]. The *S/N* figure should be as high as possible for a given system.

SIMM (Single In-Line Memory Module)

A small circuit board containing chips used to increase the **RAM** of a computer.

Simultaneous contrast

Where the eye's perception of brightness is affected by the intensity of the surrounding area.

Simultaneous contrast: The grey tone, and red colour in the pairs are the same, yet appear to be different due to the visual influence of the frame surrounding them.

SmartMedia® (SM)

Small (45 mm × 37 mm × 0.76 mm) and light (approximately 2 g) memory card for **digital cameras**. The controller is located in the drive instead of being incorporated in the card to allow simple construction.

Smearing

An **artefact** on some older **CCD** arrays when a particular pixel or group of pixels is overexposed due to imaging a particularly bright object. Smearing appears as a vertical streak above and below the image of the object or light source.

Smoothing filter

A filter which blurs (softens) a selected area. It can be used to reduce noise in an image.

SNAP (Specifications for Non-Heat Advertising Printing / Specifications for Newsprint Advertising Production)

A similar set of specifications as **SWOP** aimed at achieving consistency of advertising in a variety of printed publications on newsprint.

Soft display

Refers to the display of transient images on **televisions** or **monitors** as opposed to **hard copy** prints.

Software

Any program run by a computer.

Solid state circuit

Any electronic circuit where the various elements are composed of **semiconductor** devices such as transistors rather than vacuum tubes.

Solarization

With photographic emulsions the effect of solarization occurs with gross overexposure, and results in a reduction in density with increasing exposure. There may be a reversal of some of the tones leading to an image with a mixture of negative and positive tones. Most image processing programs like **Adobe Photoshop®** have a 'solarize' filter, and the effect can also be achieved manually by manipulation of the tone **curve**.

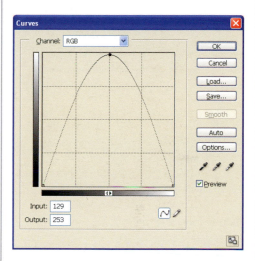

Solarize: The image has been solarised using the curves control as shown in the dialog box reversing the density of all tones above the mid-tone.

SPARC (Scalable Process Advanced RISC Computer, or Scalable Performance ARChitecture)

A 32 bit **RISC** based computer developed by Sun Microsystems®.

Spatial frequency

In digital imaging, brightness value. The change of brightness value from pixel to pixel is referred to as spatial frequency change. If closely spaced pixels change brightness values rapidly, this is described as high frequency information. Low frequency information is minimally changing pixel brightness.

Speckling

Another term for the **noise** which appears as isolated light toned pixels in dark image areas.

Spectral

Relating to the spectrum, in particular the variation in response or **output** with wavelength.

Spectral energy distribution

The energy **output** of a source related to the wavelength of the emitted radiation. Light sources have spectral energy distribution curves from which the performance and suitability can be ascertained.

Spectrum

See **Electromagnetic spectrum**

Specular highlight

A part of the image showing a bright source of light, such as the reflection in a mirror or a streetlamp at night.

Spot

The smallest diameter of light that a **scanner**, **filmwriter** or **imagesetter** can expose. The smaller the spot size, the higher the resolution of the device.

Spot colour

The use of a non-process colour, usually a fifth ink, in the printing process. Company logos often use specific spot colours for purposes such as corporate identity.

sRGB

A multipurpose colour space originally developed for consumer imaging devices such as cameras and **scanners**. It is a good space for web work, but generally unsuitable for high quality reprographics work.

SRF (Sony RAW file format)

The **RAW** file format (.srf) generated by Sony® **digital cameras**.

SSFDC (small storage for digital cameras)

An alternative name for **SmartMedia**® **memory cards**.

Stitch

The process of joining together two or more overlapping images for the production of **panoramic** images.

Stochastic screening

An alternative to conventional screening that separates an image into very fine, randomly placed

dots as opposed to a grid of geometrically aligned **halftone** cells. It is similar in concept to **mezzotint**, but whereas in a mezzotint the dots are meant to be large enough to be visible, with stochastic screening, the dots must be so small as to be invisible.

Stylus

The name given to the pen shaped pointing device used on a graphics or **digitizing tablet** to perform the function of moving the **cursor** on the screen. Some styli are 'pressure sensitive', so that the more the pressure used, more the **paint** applied to an image, and some can be reversed to act as an eraser.

Sublimation

The process by which a solid becomes a gas without first passing through a liquid phase.

Subtractive primary colours

Cyan, magenta and yellow are the complementary colours to red, green and blue respectively.

Super CCD®

The Super CCD® developed by Fuji uses octagonal rather than square pixels, enabling a greater surface area per pixel. The latest generation, the Super CCD SR and HR incorporate both large, high-sensitivity S-pixels and smaller R-pixels for greater **dynamic range**.

Supersampling

Many **scanners** and other devices such as **digital cameras** can differentiate more than 256 tonal levels (8 bit) for each **RGB** colour. Values of 10, 12, 14 or 16 bits are capable by some devices.

SVCD (super video CD/ super video compact disc)

A type of CD having the capacity to hold about 35–60 min on 74/80 min CDs of very good quality

full-motion video along with up to two stereo audio tracks and also four selectable subtitles. A SVCD can be played on many standalone **DVD** players as well as computers.

SVF (still video floppy)

The 5 cm magnetic disc used in electronic **still video** cameras to store **analogue** image, and in some cases, sound data as well.

SVGA (super video graphics array)

A CRT resolution of 800×600 pixels at 256 colours minimum. At this resolution, the **CRT** is **non-interlaced** and has a high refresh rate to limit **flickering**.

SV (still video)

The name given to the first range of electronic still cameras employing a solid state pick up device (**CCD**) in the focal plane, and recording the **analogue** signal on a SV floppy **(SVF)** disc (or **memory card**) for subsequent playback. The discs can record 50 low resolution *field* images, or 25 high resolution *frame* images together with a limited amount of audio. The discs can be erased and re-recorded.

SWOP (specifications for web offset publications)

Technical guidelines produced by SWOP, Inc. specifically for printers of magazines, but also used extensively by commercial printers. They relate to such things as dot gain, inking requirements, and recommended **shadow** areas.

Syquest®

Proprietary name given to a range of removable **hard discs** (now largely obsolete) ranging in capacity from 44 to 200 MB.

Tt

TA

See **Thermo-autochrome**®

Targa™

See **TGA**

TCP/IP (Transmission Control Protocol/Internet Protocol)

A set of protocols that define the **Internet**, i.e. the exchange of data between connected computers. It was originally designed for **UNIX**® systems but is now available for most types of computer platforms. A computer must have TCP/IP software to link to the Internet.

Telecentric

An optical design where essentially parallel rays of light strike the imaging surface, be it a film or a digital sensor.

Television

The system of transmitting electrical signals for the reproduction of images (and sound) at a distance.

Terabyte (TB)

One trillion bytes.

Terminal

A computer attached to a network. A 'dumb terminal' is a machine which does not have its own **software** or **hard disc** for storage.

TFT (thin film transistors)

A type of **LCD** flat-panel display screen in which each pixel is controlled by one to four transistors. TFT technology provides the best resolution of flat-screen monitors but it is also the most expensive. TFT screens are sometimes called **active matrix LCD**s.

TGA (Targa file format)

A **file format** used for saving and transferring 24 bit files between computers using TrueVision® video boards.

Thermal printing

A range of printing devices which utilize heated rollers to transfer the printing medium onto paper.

Thermal dye sublimation printer

This method of printing uses a system of transferring dyes from magenta, yellow, cyan and, in some machines, black ribbons onto a paper surface. A heating element the width of the paper vaporizes (by **sublimation**) the dye on the donor ribbon surface which is then absorbed into the surface of the paper. The image is generated by applying three or four passes of the donor ribbon to a single sheet of paper. The registration of the paper during each pass is crucial to the quality of the final image. As the dyes are transparent, each pixel on the page can represent any colour by varying the amount of the three (or four) colours. The action of the dye in being absorbed into the paper also means that the individual pixels join together to form a seamless area of colour similar to a true photographic print. Many models have an ultraviolet absorbing filter layer which is applied to the paper surface to reduce fading.

Thermal wax transfer printer

This printing method works by heating coloured wax sheets and melting it onto a paper surface. The wax is transferred or 'ironed' onto the paper by thousands of individually controlled heating elements each heated between 70 and 80°C which will melt a tiny pinpoint of colour. Colour is created by a four pass system, cyan, magenta, yellow and black. These units tend to be relatively inexpensive.

Thermo-autochrome®

A **photo-realistic** printing system developed by Fuji®, which uses special paper consisting of three dye layers (cyan, magenta and yellow) plus a heat resistant layer coated onto the surface. Within each layer, 1 μm diameter microcapsules are embedded, which produce a dye in proportion to the amount of heat received from the printer's thermal heads. The effective resolution is 300 dpi.

Thin film transistors

See **TFT**

THM (Canon thumbnail image file)

Files created by most Canon® cameras supporting **CRW** files. These thumbnail files contain a small 160 × 120 preview of the original image in the associated CRW file, plus the **EXIF** information and optionally **IPTC** information. The THM files always have the same name as the original CRW file, but with a .THM file extension (suffix).

Three quartertone

The tones in between the **highlight** and **midtone**, or midtone and **shadow**.

Threshold

A particular brightness value which determines a transition. For example, in one instance, all pixel values above the threshold level may be assigned black, and all pixels below the threshold level may become white, thus creating a **binary** image.

Throughput

The amount of material put through a particular process or machine.

Thumbnail

A very low resolution version of an image used for sorting and finding images.

TIFF (tagged image file format)

Probably the most widely used of the image **file formats** available today for **bitmapped** images. It was designed in the late 1980s by Microsoft® and Aldus® to try to standardize on the growing number of images being produced from **scanners** and **digital cameras**, and to allow transference of the image from one **platform** to another. There are several versions in existence, though these usually cause no problems when using the format. When saving images in **TIFF** form, the user can choose the option of **PC** or **Macintosh** platform, and also whether to employ **LZW** compression or not. This is a **lossless compression system,** i.e. no data is lost during the compression process.

A TIFF file is made up of two parts, the image data, and a header, where information relating to the size, resolution and **bit depth** of an image is defined.

TIFF/EP (tag image file format for electronic photography)

A version of TIFF used by Kodak® digital cameras to store non-image data such as date, time and exposure details with many different types of image data.

TMA (transparent materials adapter)

An adapter containing a light source enabling a **flatbed scanner** to scan transparent materials such as negatives and transparencies.

Tonal range

The range of tonal densities or values within an image.

Tone reproduction

The relationship between the tonal range of the original subject or image, and the final reproduction.

Toolbox: The toolbox from Adobe Photoshop CS showing a range of selection tools, drawing and painting tools, as well as color palettes and Quick Mask mode.

Toolbox

A visual palette of the tools available within image processing programs such as **Adobe Photoshop**®.

Total pixels

The total number of pixels present in an **imaging sensor**, though not all will be used in actual image production.

> *See* **Effective pixels**

Touch screen

A computer **monitor** which is touch sensitive and allows the viewer to access information by touching certain areas of the screen. They are used in museums, art galleries and the like.

Track

A band of data on a recording medium.

Trackball

A large rotatable ball which replaces a **mouse** for moving the **cursor** and other tools around on the screen.

Transfer rate

The rate at which data is transferred usually from one disc drive to another.

Transfer register

See **Shift register**

Transparency

1. Silver halide emulsion which, when developed by a reversal process yields a positive image on a transparent base.
2. A transparent output from a digital printer such as a **thermal dye sublimation printer**, particularly for use in overhead projectors.

Trapping

The slight, deliberate, overlap of two colours to eliminate gaps that may occur in slight mis-registration of printing plates.

Triad

The arrangement of three phosphor dots (red, green and blue) which are excited by the electron beams in a colour television system.

Trichromatic

Three-colour.

Trilinear array CCD

See **CCD**

Tritone

See **Duotone**

True colour

A term used to describe the **photo-realistic** quality given by 24 bit computer displays.

TrueType®

A font format created by Microsoft® and Apple® Corporations.

Trumatch®

A colour matching system similar to **PMS**. Not widely used.

Tube

See **CRT**

TWAIN (technology without an interesting name)

A cross-platform interface for acquiring images with **scanners** and **frame grabbers**.

Tweening (in-betweening)

In computer animation, where the operator describes the first frame of a sequence and another later on in the sequence and the computer generates the frames in-between.

Uu

UCA (under colour addition)

The practice of adding cyan, magenta and yellow to areas that are predominantly black in order to achieve a richer and darker colour.

UCR (under colour removal)

A process for improving the quality of colour reproduction by changing the relative balance of the inks applied. The amount of yellow, magenta and cyan inks is decreased, whilst the amount of black is increased.

Ultraviolet

Electromagnetic radiation between approximately 100 and 400 nm. Silver based film emulsions are sensitive to shorter wavelengths. **CCD** and **CMOS** sensors are also inherently sensitive to ultraviolet, though most chips are coated with a filter to absorb it. Some manufacturers supply the chips without the filter for specialist scientific applications. Glass lenses do not transmit ultraviolet well, and if the prime requirement is ultraviolet imaging, it may be necessary to use lenses constructed from materials such as quartz which transmit large amounts of ultraviolet.

UNIX®

A computer operating system designed specifically for multi-user systems. Servers on the **Internet** invariably use UNIX.

Undo

A standard command found in most computer programs to revert to the previous version of a saved document. Several imaging programs allow multiple levels of 'undo'.

URL (uniform resource locator)

The standard naming and addressing system on the **World Wide Web**. For example, the URL of

Kodak's digital imaging page devoted to professional **DSLR** cameras is: http://www.kodak.com/global/en/professional/products/cameras/proSLRc/proSLRcIndex.jhtml

USB (Universal Serial Bus)

A computer port (socket) for connecting peripheral devices such as **scanners**, cameras and printers. The cable can carry a current (up to 500 mA at 5 V) so that devices can draw their power through the USB cable. Up to 127 devices can be connected to USB hubs. Individual USB cables can be as long as 5 m, whilst hubs can be up to 30 m away from the host. USB devices are hot-swappable, meaning that they can be plugged into the bus and unplugged at any time.

USB 2.0

A faster version of **USB**, USB 2.0 (high-speed USB) provides additional **bandwidth** for multimedia and storage applications and has a data transmission speed up to 40 times faster than USB 1. USB 2.0 has full forward and backward compatibility with original USB devices, and works with cables and connectors made for the original USB standard.

USM (Unsharp masking)

A procedure for increasing the apparent detail of an image, performed either by the input scanner or by the image processing program.

Unsharp masking (USM) is a widely used **tool** found in the majority of image processing programs such as **Adobe Photoshop®** for increasing the apparent sharpness of images. The rather confusing name is derived from an old technique used in the printing industry whereby, to increase sharpness, an unsharp negative is sandwiched with the original positive during exposure. Edge sharpness was increased as a result.

Unsharp masking works by increasing the contrast between pixels, creating sharper edges,

Unsharp Mask dialog box in **Adobe Photoshop®** CS

rather like **acutance** developers in film development.

In the example shown, two grey boxes have been generated, and an unsharp mask filter applied to sharpen the boundary between them. Note the thick line (**halo**) between the two boxes and how they are graduated from dark grey to black and light grey to white. Plot profiles (created in Scion Image) show the exaggerated boundary.

In practice, the unsharp mask dialog box has three controls, amount, radius and threshold.

Amount can be likened to the volume control on an amplifier. The higher the amount the more pronounced the effect.

Radius determines the range of pixels on either side of the edge boundary where sharpening will occur, and determines the size of the 'halo' around edges.

Threshold controls the number of pixels to which sharpening is applied, based on the brightness

The effect of unsharp masking shown at the edge boundary of the two grey tones. The resulting plot profile shows greater contrast at the edge (profiles generated in Scion Image software).

Two grey tones and a plot profile showing abrupt change between the two tones.

difference of neighbouring pixels, i.e. how different pixels have to be before they are treated as edge pixels. A setting of 0 will result in all different pixels being altered, which could lead to degradation of subtle areas of tone such as skies.

Typical values might be:
Digital camera images 3–5
Scans of colour negatives: 10–15

In practice, sharpening should be the last operation in the imaging chain before output as any **resampling** of the image may increase **artefacts** in the sharpening process. Try to evaluate the effect using the actual output rather than the monitor display.

Note: *If you are supplying digital files to picture libraries or reproduction houses, the usual advice is not to sharpen images as the images may be sharpened routinely by the operatives there.*

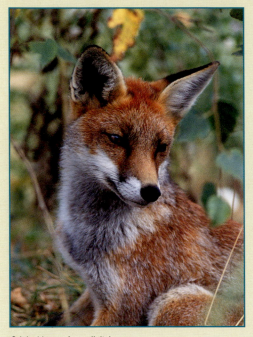

Original image from digital camera.

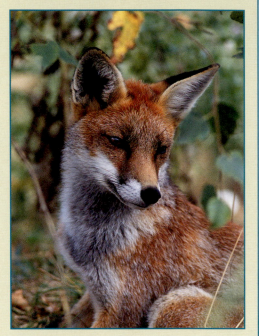

Image sharpened, using settings of amount 200%, radius 1.0, threshold 10.

Usenet

A worldwide system of discussion groups.

UV Diagram

Type of chromaticity diagram introduced by the CIE in 1960, now superseded by u',v'

U',V' Diagram

Uniform chromaticity diagram introduced by the CIE in 1976.

UXGA

A monitor display of 1600 × 1200 pixels

Vv

VCD (video compact disc)

A **CD** that contains moving pictures and sound. A VCD has the capacity to hold 74–80 min on 650–700 MB CDs, respectively, of full-motion video along with quality stereo sound. VCDs use the **MPEG** compression standard to store video and audio.

VGA (variable graphics array)

An electronic display standard that defines a resolution of 640×480 pixels with a 16 colour capability, and 320×200 pixels resolution with a 256 colour capability.

Vector

Vectors are used to describe lines or create objects on a computer. They use mathematical formulae to define lines and shapes, for example, a circle can be defined by $x^2 + y^2 = z^2$.

Vector graphics

A type of computer graphics where images (geometric shapes such as curves, arcs and lines) are defined as a series of mathematical formulae rather than a grid of pixels.

Also referred to as **object-oriented** graphics.

Vertical scan rate

The rate at which two interlaced **fields** scan to give a complete video **frame**.

See **Flicker**

Vertical smear

An **artefact** on some **CCD** designs where a vertical streak is seen above and below a bright object.

Video

The **analogue** electrical signal generated through the action of light falling upon an **image sensor**

such as a video imaging tube or **CCD image sensor**.

Viewing conditions

The environment in which artwork or transparencies are evaluated.

Visually lossless compression

The compression system used by **PhotoCD**, which uses chroma (colour) subsampling and relies on the limitations of human vision, whereby colour information is not as important as detail. Colour information can therefore be discarded more readily than detail before it is perceived. In the case of PhotoCD the loss is visually lossless.

Viewing distance

The distance from which an image is viewed. The 'correct' viewing distance for an image – to ensure that the perspective is the same as the camera image – is the camera image distance for a contact print times the magnification. For example, if a negative was made with a 50 mm lens and a 10x enlargement is made, then the correct viewing distance will be 50 mm \times 10 = 500 mm.

Virtual memory

A technique for increasing the apparent size of memory available by using memory from the **hard disc**. It is generally very slow.

Virus

A computer program deliberately written with the malicious intention of disrupting the normal operation of a computer. Some viruses 'infect' files only, whilst others can destroy application programs, operating systems, or erase large amounts of data. Virus protection software is available, but by its very nature, will always be one step behind the author of the virus.

132 Volatile memory

Memory systems such as Dynamic RAM (**DRAM**) and Static RAM (**SRAM**) where the data is lost when power is switched off.

See **Non-volatile memory**

VRAM (video random access memory)

The memory which stores the image displayed on the computer monitor. The amount of VRAM required for specific **bit depths** with different sizes of **monitor** can be calculated from: VRAM required = Bit depth \times (horizontal resolution \times vertical resolution).

Ww

WAN (wide area network)

Any network covering an area larger than a single building or site.

Wavelength

The distance, on a waveform, from the peak of one wave to the corresponding point in an adjacent period. The wavelength of visible light, part of the **electro-magnetic spectrum**, is approximately 400–700 nanometres (nm).

Web

A common term for **World Wide Web** – a part of the **Internet**. A website usually consists of a **home page** and other linked pages. Links to other pages or sites are made using hyperlinks – for example, text, graphics or images can be 'clicked' to access other information, or higher resolution versions of images. When preparing images for web pages, they should be re-sized to a resolution of 72 ppi (the resolution of most computer monitors), and to the size they are needed on screen, e.g., 640×480 pixels.

White balance

The relative amount of red, green and blue in a light source. Digital and video cameras can be ' white balanced', i.e., the signal adjusted so that the light reflected from a white or neutral grey surface can be neutralized.

White light

A light source composed of equal amounts of red, green and blue wavelengths.

White point

A movable point on the image **histogram** which defines the lightest part of the image. Any areas with a value less than this will automatically be recorded as white.

WiFi (wireless fidelity)

The term generally used when referred to any 802 (a family of specifications developed by the **IEEE** for wireless technology) type of wireless network.

Window

An area of the computer display which shows the contents of a folder, disc or document. Several windows can be open at the same time, although only one can be active. They can be moved around the screen, and may have their size changed.

Windows®

The name given to Microsoft's **Graphical User Interface (GUI)**. Current versions are Windows® 2000 and XP.

Wireframe

A technique in computer graphics whereby complex shapes are drawn as a series of polygons in the form of a **wireframe**, which can later be **rendered** with a surface texture.

Workflow

The sequential stages in the passage of an image: input → download → display → preparation for output → final output.

WORM (write once, read many times)

An **optical disc** that can only be recorded once with data. This cannot be erased or modified.

Wraparound

1. In word processing, when the end of a line is reached, the computer automatically puts characters onto the next line.
2. In some image processing programs, a value above 255, or below 0 automatically wraps round the next higher or lower value, so a value after 255 becomes 0, and a value below 0 becomes 255.

Write

To record data onto a disc.

Write protected

Where a disc is protected against accidental erasure of data. Usually achieved by sliding a small plastic tag across a hole in the outer casing of the disc.

WWW (World Wide Web, or often, 'The Web')

A part of the **Internet** consisting of many thousands of pages/documents written in **HTML**, which enables attractive page layouts, graphics, digital images, and **multimedia**, and **hypertext** links to other pages and sites. To view the sites and pages, **browser** software such as, such as Netscape® and Microsoft Internet Explorer® are required. There are extensive search facilities within the Web by means of 'search engines' such as Lycos®, and Yahoo®.

WYSIWYG (what you see is what you get)

Refers to the relationship between the screen display and final output.

Xx

xD Picture Card (extreme digital)

A type of memory card for **digital cameras**, currently the smallest physically on the market, with capacities up to 1 GB, though it is anticipated capacities up to 8 GB will become available.

xRes™

An image processing program which uses a **proxy** formula to represent large images in xRes native format. Any changes made to these files must be applied to the final output file.

X3® sensor

The name given by Foveon® to its multilayer imaging sensor.

See **Image sensors**

XMP (eXtensible Metadata Platorm)

Adobe's Extensible Metadata Platform is a labelling technology that allows the embedding of **metadata** into the file itself. The files are stored as **sidecar files** in the same folder as the **RAW file**, with the same file number, with an XMP extension. These files can be used to store **IPTC** data or other metadata with a camera raw file.

XVGA (Extended Video Graphics Array)

A monitor screen resolution of 1024×768 pixels.

135

Yy

Y

The term used to describe the **luminance** part of the **YCC** format.

YCC

A colour model which is the basis of Kodak's **PhotoCD** system. The YCC format has one **luminance** (Y) and two colour, or **chrominance** channels (CC).

Young–Helmholtz Theory

The hypothesis that there are three different light sensitive receptors (cones) on the human retina, sensitive to red, green and blue light, and that all other colours can be constructed through the relative stimulus of these receptors. First proposed in 1801, the theory is largely accepted, on the basis of physiological evidence.

Zz

Zip® drive

A form of removable **hard disc** storage using 3.5 in. discs of 100, 250 and 750 MB capacity.

ZLR (zoom lens reflex)

The name often given to a digital single lens reflex camera with a non-interchangeable zoom lens.

Zoom

1. In photography and imaging – a lens of variable **focal length**, for example 35–70, 80–200 mm. Manufacturers often quote a figure for the amount of zoom available in a lens, for example, a 10x zoom on a digital compact camera might have a range of focal lengths from 6.3 to 63 mm.
2. In image processing – to enlarge (zoom in), or reduce (zoom out) the image.

See **Optical zoom**; **digital zoom**

138

References

There are many thousands of websites devoted to **digital cameras**, imaging techniques, colour management and other topics. I have listed here just a few that I have found particularly useful or interesting.

www.adobe.com
Site for Adobe's product information plus many tutorials and **FAQ**s.

www.apple.com
Site for Apple® Macintosh® computers, but which also contains a large amount of information and tutorials on digital imaging and Photoshop.

www.canon.com
Site containing product information about Canon® cameras and equipment.

www.colourconfidence.com
Site of a company providing various colour management equipments, together with excellent downloadable information documents.

www.colorvision.com
The website of a company supplying various colour management tools.

www.computer-darkroom.com
The website of Ian Lyons, digital imaging expert. Contains many useful articles and tutorials.

www.digitaldog.net/
The website of Photoshop expert Andrew Rodney. Contains a large amount of downloadable **PDF** documents on colour management, digital cameras and scanners.

www.dpreview.com
A remarkably comprehensive site offering impartial reviews on most digital cameras, as well as having highly informative articles on various imaging topics.

www.epson.com
Site containing product information about Epson® printers and scanners.

www.foveon.com
Site containing information about the **Foveon**® **imaging sensor**.

www.fujifilm.com
Site containing product information about Fuji® cameras and equipment.

www.gretagmacbeth.com
The website of a company providing various colour management tools including the **Macbeth** Colorchecker Chart.

www.imageplace.co.uk
The website of a small company providing remote printer profiling and other colour management services.

www.iqa.org/digital/digital_draft.shtml
A document put together by a group of imaging experts (the Institute of Quality Assurance Digital special interest group), to try and introduce industry guidelines for best practice with digital imaging workflows.

www.kodak.com
Site containing product information about Kodak® cameras and materials.

www.luminous-landscape.com
An excellent site with tutorials, articles and many image galleries.

www.martinevening.com
Website of the author of the Focal Press book: *Photoshop CS for Photographers*. This site contains much useful information.

www.naturfotograf.com
An interesting site with camera and lens reviews, and several image galleries including infrared and ultraviolet imaging.

www.nikon.com
Website containing product information about Nikon® cameras and equipment.

www.olympuspro.com
Website for product information about Olympus®
cameras and equipment including the Olympus 4/3
system.

www.pixl.dk
The website of a Danish company offering many
colour management services including remote
profiling.

www.pixelgenius.com
The website of Photoshop expert Bruce Fraser,
author of many books including *Camera Raw with
Adobe Photoshop CS*.

www.robgalbraith.com
The website of Rob Galbraith, ex Canadian
press photographer, now digital imaging
consultant, and one of the first users of digital
cameras. Contains many useful reviews, articles
and discussion groups.

www.russellbrown.com
The website of Photoshop expert Russell Brown,
with many useful tutorials.

www.scioncorp.com
The site for downloading 'Scion Image', scientific
imaging software, together with a host of
information and sample images.

www.stevebloom.com
The website of renowned wildlife
photographer and digital imaging expert Steve
Bloom. Contains superb images using digital
technology.

Adobe Photoshop CS2 A - Z

Philip Andrews and Peter Bargh

- Provides a comprehensive listing of key tools and features included in the latest Photoshop version, CS2
- Saves time for all users, from beginner to advanced, with the dip-into A-Z format
- Written by internationally known teacher and author with Adobes' Photoshop Quality Engineer's seal of approval

This is a superb easy-to-navigate ready reference to Photoshop. You can look up all the menus, tools and features to find out exactly what you can do with them, including all those in the latest version - Photoshop CS2.

Solve problems as you work by dipping in to find out about a particular feature, or work through each feature in turn. Each topic is beautifully illustrated and covered succinctly with cross-references to related areas.

The supporting website, www.photoshop-a-z.com provides high resolution royalty free images to download, QuickTime tutorials, useful links and resources.

ISBN: 0240520025

For more details and to purchase a copy online visit www.focalpress.com

Also available from Focal Press

Adobe Photoshop CS2 for Photographers
A professional image editor's guide to the creative use of Photoshop for the Macintosh and PC

Martin Evening

'still the daddy of all Photoshop books'
British Journal of Photography

- Master the power of Photoshop CS2 under the instruction of an internationally recognised Photoshop expert
- Over 450 professional, color illustrations make this book stand above the rest
- 704 pages of fully updated content plus 30 pages of Photoshop Shortcuts on the free CD-ROM.

The seventh edition of Martin Evening's bestselling 'Adobe Photoshop for Photographers' titles, gives you completely updated and revised coverage providing a professional photographer's insight into Photoshop CS2.

Packed full of all the latest features and instructive information on key elements from color management to printing, Martin Evening passes on his famous techniques and professional experience in this commanding and authoritative resource.

May 2005: 189 X 246 mm: Paperback:
0-240-51984-1

To order your copy call +44 (0)1865 474010 (UK) or +1 800 545 2522 (USA)
or visit the Focal Press website: www.focalpress.com

Also available from Focal Press

Digital Imaging: Essential Skills

Mark Galer and Les Horvat

- Benefit from a very practical teaching approach, building on your competences
- Achieve a comprehensive understanding of the entire digital chain, from capture to print
- FREE CD-Rom includes over an hour of video tutorials, supporting inspirational images, printable PDF files, Adobe presets and lots more

If you want to understand the entire digital chain, from capture to print and produce stunning digital images, then this is the book for you. Using established teaching techniques, which take a practical approach, focussing on building on your competences through creative assignments and practical activities, you will achieve a solid understanding of the principles of digital imaging.

With new sections on colour management and managed workflow, Camera RAW and 360 degree panorama creation and object movies created from digital stills for the web. The free CD-Rom is packed full of additional resources, including RAW files to use as a learning resource, allowing you to put skills into practice.

May 2005: 189 X 246 mm: Paperback:
0-240-51971-X

To order your copy call +44 (0)1865 474010 (UK) or +1 800 545 2522 (USA)
or visit the Focal Press website: www.focalpress.com

Adobe Photoshop Elements 3.0 A - Z

Philip Andrews

- Full colour, fully illustrated comprehensive A to Z listing of key tools and features included in the Adobe Elements version 3.0
- Saves time for all, from beginner to advanced, with the dip-into A-Z format
- Written by an internationally known teacher, author, Elements guru and Elements Alpha tester and approved by Adobe's Photoshop Elements Quality Engineer

This is a superb easy-to-navigate compilation of all the tools and features offered in the best-selling Photoshop Elements 3.0.

You can dip in and out of this book or work through feature by feature. Each topic is covered succinctly and is cross-referenced to related topics. Illustrated throughout with high-quality full colour photographs and screenshots.

The supporting website: www.elementsa-z.com, provides royalty free high resolution images and QuickTime video tutorials.

ISBN: 0240519892

For more details and to purchase a copy online visit www.focalpress.com

Also available from Focal Press

How to Cheat in Photoshop, 3rd Edition
The art of creating photorealistic montages

Steve Caplin

"Well-written, insightful and beautifully illustrated."
Digital Creative Arts

- Extensive new material to show you how to take your
 Photoshop skills even further
- CD includes all the images from the book and 100 new,
 free, high resolution AbleStock images
- Benefit from a professional illustrator's timesaving tips
 and tricks!

With this book you can work from the problem to the
solution with expert guidance from a professional illustrator.
Each section is divided into color double page spreads on
illustrative techniques; giving bite size chunks with all that
you need to know in a highly visual, approachable format.

Most of the original Photoshop files are provided on the free CD, along with hundreds of dollars'
worth of free, sample plugins and images, so you can try out each technique for yourselves as
you read.

August 2005: 189 X 246 mm: Paperback:
0-240-51985-X

To order your copy call +44 (0)1865 474010 (UK) or +1 800 545 2522 (USA)
or visit the Focal Press website: www.focalpress.com